GREAT MASTERS OF
FRENCH IMPRESSIONISM

GREAT MASTERS OF
FRENCH
IMPRESSIONISM

INTRODUCTION BY

J. CARTER BROWN
Director, National Gallery of Art, Washington

COMMENTARIES BY

DIANE KELDER

AN **Artabras** BOOK

CROWN PUBLISHERS, INC. NEW YORK, N.Y.

On the JACKET:
Children Playing on the Beach
Commentary on page 102

Great masters of French impressionism from the National
 Gallery of Art, Washington, D.C.

 1. Painting, French—France. 2. Painting, French—
United States—Washington, D.C. 3. Painting,
Modern—19th century—France. 4. Painting, Modern—
19th century—United States—Washington, D.C.
5. Impressionism (Art)—France. 6. United States.
National Gallery of Art. I. Kelder, Diane.
II. United States. National Gallery of Art.
ND547.5.I4G73 759.4'074'0153 78-862

ISBN 0-89660-030-0

CONTENTS

INTRODUCTION

BY J. CARTER BROWN,

Director, the National Gallery of Art, Washington

WHY? Why a book on the Impressionists that limits itself to pictures at the National Gallery of Art? Why a book about the Impressionists at all?

The short answer to both questions is the same word, a concept fundamental to the Impressionist approach: celebration. Until a generation ago the United States did not have a national gallery in the tradition of the great capitals of Europe. Today it can celebrate a great national treasure house in Washington that, as this is written, is on the brink of doubling its size. In it is one of the greatest collections of Impressionist and post-Impressionist painting in the world. But beyond that the Impressionists themselves celebrated life. Anyone who turns the pages of this book or, better still, comes to see the originals in their setting on the national Mall can share in that joy.

It is a curious fact that as one comes to know the great national galleries and museums in the capitals of Europe, one recognizes how few of them, however great their treasures in other fields, manage to survey the full range of achievement in late-nineteenth-century French painting that we have come to label generically as Impressionism. Some of the greatest institutions do not have a single example of work in this school. France herself came rather late into the official recognition of these paintings' importance, with Gustave Caillebotte pleading with the authorities to allow him to give the pictures he had lovingly collected by the great figures of the Impressionist movement he had so intimately known. Curiously, it was Americans who were among the first to begin collecting in this school: the Havemeyers in New York, buying on the advice of the American artist Mary Cassatt, who exhibited her own paintings along with the French Impressionists; and in Chicago the indomitable Mrs. Potter Palmer, whose pioneering purchases now grace the Art Institute in that city. Although P. A. B. Widener considered his own collecting to be focused on the earlier masters, he could not resist a few purchases, considered highly adventurous in his day, such as the lovely Degas, Renoir and Manet illustrated in this book. Two more of the important Manets hang at the National Gallery thanks to the Havemeyer family.

In terms of sheer quantity alone, the National Gallery of Art has the largest collection of French Impressionist and post-Impressionist painting in this hemisphere. Its collection of forty-six Renoirs must be the largest collection of that artist's work anywhere.

In addition, the Gallery looks forward to the continuing generosity of American collectors. The Gallery's president, Mr. Paul Mellon, and Mrs. Mellon have the most comprehensive collection of French Impressionist and post-Impressionist painting in private hands.

Luckily the original building of the National Gallery was constructed with large unfinished spaces that are slated to be converted in the future into exhibition rooms for paintings of this period. The construction of a second building, made possible by the generosity of Mr. Mellon, his late sister, Ailsa Mellon Bruce, and The Andrew W. Mellon Foundation, will greatly alleviate the space shortages in the original building in a variety of areas, and allow the collections to continue to grow in the art of the twentieth and hopefully succeeding centuries, without compromising the Gallery's intention to be one of the greatest centers for the study of French Impressionism in the world.

Quantity, of course, is not the only touchstone. This book is a testimonial to the degree to which quality also characterizes the national collections. Every one of its paintings in this field has been purchased by a private citizen, and not by the Gallery itself, which receives no governmental appropriations for the acquisition of works of art. Americans can be particularly grateful that the gifted and sensitive Maude Dale, herself an artist, interested her energetic husband, Chester, in beginning—with the later help of Mr. Dale's second wife and now widow, Mary—a dazzling chapter in the history of collecting we now know as the Chester Dale Collection. The saga of the collection, and its sometimes precarious relationship to the National Gallery, is recounted elsewhere by the former Director, John Walker, whose long-term involvement with the Dales—and that of his predecessor, David Finley—resulted in the collection's coming to the nation in its entirety.

Despite the Dales' opportunity to acquire major masterpieces before the market in French Impressionists had become so astronomically prohibitive, it is interesting that of the pictures in this book, almost half come from other collections.

The Honorable W. Averell Harriman was recently responsible for the gift of a magnificent collection of nineteenth- and twentieth- century paintings, three of which are included here. One of Governor Harriman's considerations in selecting the National Gallery for his donation was the program of the Gallery's National Lending Service, which has been put into effect as part of its federal mandate to serve institutions across

9

the land, thus freeing the Gallery from the concept of a restricted physical entity in Washington.

One of the most beautiful paintings in the book came to the Gallery not in a collection but as a single painting in the estate of Mr. and Mrs. Benjamin E. Levy. It stands as an example of another Gallery policy, which is to include wherever possible a recognition of the achievement of major American collectors, even when their commitments elsewhere allow for only a single picture to be represented in the capital.

Some of the most delightful paintings illustrated on the ensuing pages came in the bequest of Ailsa Mellon Bruce, the daughter of the Gallery's founder, whose generosity to the Gallery in other ways has been such an important factor in its continuing growth. Of those paintings included from the collection of Mr. and Mrs. Paul Mellon, some have already been given to the National Gallery and others are on indefinite exhibition here. Each one—the Manet, the Cézanne, the Degas, the Seurat and that enchanting Monet, *Woman with a Parasol*—represents an outstanding example by its artists and bears witness to the eye and uncompromising standard of quality that characterize Mr. and Mrs. Mellon's collections.

Although the National Gallery's representation of other great moments in art history (particularly painting and sculpture of the Italian Renaissance, of which it again has this hemisphere's most comprehensive collection) contains many masterpieces, it is the French Impressionist galleries that are the most heavily visited, and it is for reproductions of these pictures that we have the greatest demand. Why?

These are the same artists who just over a century ago were ridiculed and reviled.

The appeal is at many levels. Not the least of them is the subject matter involved—the idyllic landscapes, the innocence of childhood, the beauty of women, the freshness of nature. Part of that appeal must be the cheerfulness of the high-key palette, the joy in color for its own sake.

What speaks to us more deeply, perhaps, is the interplay between two life forces that hold us in their grip: light and time.

With a rush of optimism about scientific inquiry; with the new, passive ability to record visible reality with the development of photography; with the break-up of an old social order and the Romantic glamour of the inspired, revolutionary individual, this age produced a small band of dissidents whose apparent radicalism was in fact a return to a hyper-conservative way of seeing. It was the beginning of a long series of circumscriptions by which artists have successively walled out ingredients that complicate the process of making art.

All around them the lineal descendants of the academic tradition were cramming their canvases with conceptual as well as perceptual data. Mythology, allegories, historical references were introduced as reinforcements to the artist's war against time.

By concentrating on light, and the retinal effects of light upon us, the Impressionists achieved timelessness by recognizing evanescence. Monet called it "instantaneity."

The Renaissance had brought the stability of the medieval universe to the one-point perspective of perception by an individual. But it was still an intellectual perception in which seeing and knowing were combined. Renaissance man lived in orthogonal spaces to which he brought a predetermined sense of order.

Starting with the tenets of Courbet and the French Realists (although in landscape there had been harbingers with Constable, with the seventeenth-century Dutch, even with Giorgione), the Impressionists dealt not with a reality they knew but with what light revealed. But light changes continuously, as the planet upon which it impinges is itself in continuous motion. Nowhere is this more apparent than on a spring day in the Île de France, with its scudding cumulus clouds and the wind ruffling the reflective surfaces of the Seine.

The paradox is that the process of painting itself occupies time, and even with his easel set up outdoors the artist is recording a memory. The subject of the paintings thus became, in a sense, increasingly the process of applying paint. As succeeding generations successively excluded the uncontrollable in their own search for timelessness, the process of art making, so intriguing to the innovative mentality of the Impressionist, gradually assumed center stage.

Meanwhile, as we look back, perhaps with a touch of nostalgia, to the moments that the artists in this book were able to capture for us, we can share with them the sense of celebration that is the gift of the artist—the gift through the eye, and the hand, to defy time.

GREAT MASTERS OF
FRENCH
IMPRESSIONISM

Édouard Manet (1832–1883)

THE OLD MUSICIAN
(1862)

THE LIFE AND CAREER OF Édouard Manet are marked by perplexing contradiction and fascinating paradox. Born to an eminent Parisian family, Manet had an elegant appearance and manners that seemed more appropriate to the drawing room than to the painter's studio. He admired the art of the past and sought conventional success, yet he chose to paint subjects that often baffled or irritated the public and the critics. From the beginning his work provoked controversy. Baudelaire called him a Romantic, while another poet, Théophile Gautier, considered him a Realist. For Émile Zola, the painter's most eloquent champion, Manet was " . . . one of the masters of tomorrow." Reactionary or visionary, Manet and his art stimulated the imaginations of the finest writers of his and subsequent generations. His paintings continue to delight us with their combination of provocative "quotations" from the art of the past and a totally fresh approach to the technique of painting that already can be seen in the largest and most ambitious of his early works, *The Old Musician*.

While a student, Manet had made copies of past art. He especially admired Velásquez. A combination of copied and directly observed figures was to remain one of the principal hallmarks of his style in the 1860s. From one of his paintings, he adapted the central figure as a model for his itinerant violinist. The mysterious top-hatted man is *The Absinthe Drinker* (1859), a Parisian ragpicker Manet had painted three years before. The artist also used real models from the slum near his studio known as "Little Poland."

The mood of this painting, with its flat forms, understated color and splintered narrative, is enigmatic. Manet never reveals the identity of his strolling players or their makeshift audience, and the romantic and realistic elements coexist rather uncomfortably. It was precisely this element of mystery and the inexplicable that angered Manet's contemporaries, prompting them to view his compositional innovations as the consequence of ineptness or affectation.

Chester Dale Collection

73¾ × 98 in (187.5 × 249.1 cm)

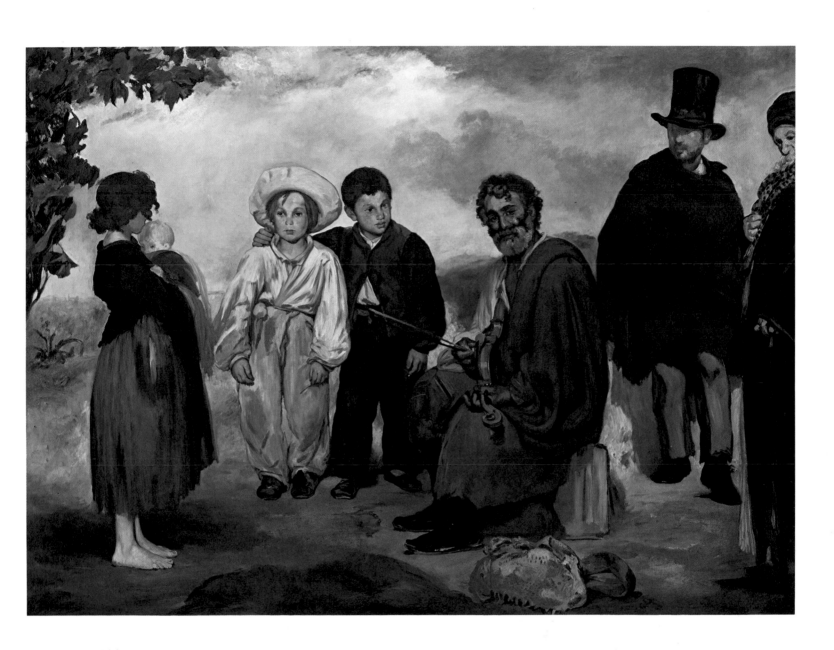

Édouard Manet

THE DEAD TOREADOR
(1864)

IN NINETEENTH-CENTURY FRANCE, the annual or biannual Salon was acknowledged as the most prestigious of national exhibitions, and all serious artists aspired toward selection and hoped for distinction, since an award was often followed by a government commission. Manet exhibited a large painting entitled *Incident in the Bullring* in the Salon of 1864, and the work was panned mercilessly by critics, who were appalled at the arbitrary scale of the figures and the general lack of spatial unity. They ridiculed Manet's predilection for Spanish themes, dubbing him "Manet y Courbetos y Zurbarán de las Batignollas"—a reference to his presumed affinity with the Realist master Gustave Courbet and to the quarter of Paris where his studio was located. Shortly after the exhibition Manet cut up the work, retaining two of its principal motifs: the bullfight scene and the figure of the fallen matador, now known as *The Dead Toreador*.

This is the first of several instances of Manet's cutting up problematic paintings, and while it is likely that he was prompted to do so because of dissatisfaction engendered by adverse criticism, it is also conceivable that he viewed the cutting up of unsuccessful paintings as another means of developing independent motifs. In a sense, the very act may be interpreted as a form of creative destruction, an alternative to the traditional reworking of a canvas.

Actually, it is not difficult to understand why critics were troubled by such elements as the extreme foreshortening of the dead bullfighter. Even today it projects a rigidity that not only precludes any sense of drama but also marks it most unabashedly as a "fragment"; but Manet was forcing the viewer to concentrate on the painting's purely formal and technical personae. In a sense, the painting functions as a human still life.

Having steeped himself in seventeenth-century Spanish painting, Manet sharpened his already highly developed appreciation of the value of blacks and grays, and his masterful brushwork is never more effective in its evocation of texture than here in the shiny satins and silks and deep rich velvets.

Widener Collection

29⅞ × 60⅜ in (75.9 × 153.3 cm)

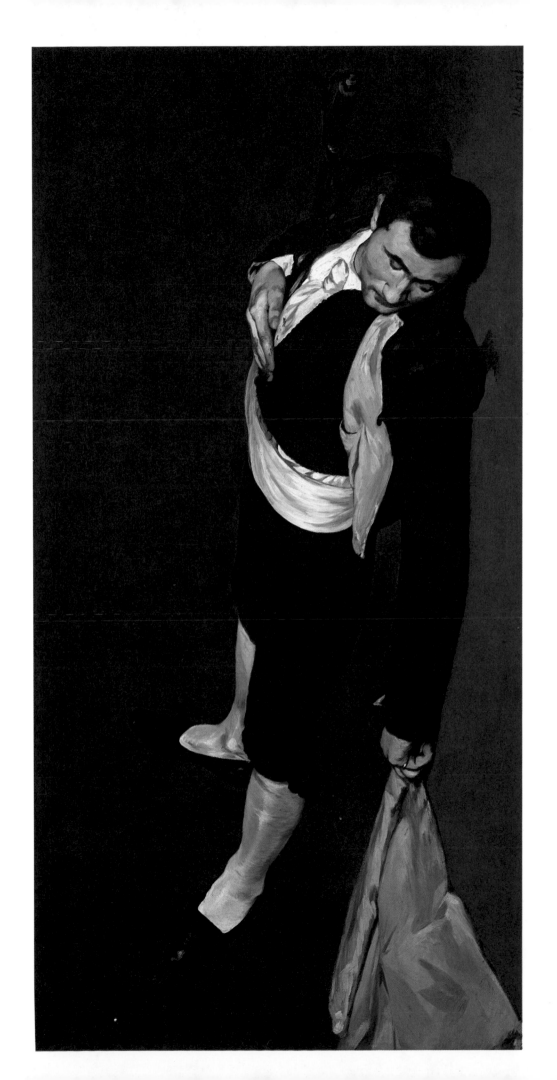

Édouard Manet

FLOWERS IN A CRYSTAL VASE
(c. 1882)

THROUGHOUT HIS CAREER Manet produced numerous still-life paintings, and his interest in them may be explained in part by his love of the seventeenth-century Spanish and Dutch schools, which excelled in this genre. Such important paintings as his *Déjeuner Sur l'Herbe* and *Olympia* contained prominent still-life elements (basket of fruits, bouquet of flowers), but the artist painted countless other traditional still-life subjects (tables with fruit, fish, wineglasses, etc.) as well. He also developed a novel type of still life in which he would represent a single melon, a bunch of asparagus or a lone brioche, letting the form fill the canvas. The very nature of a still life—undramatic, with no narrative connotations—permitted the artist to concentrate on the manipulation of paint.

Manet's friend and biographer Antonin Proust recounted the artist's delight in flowers: "I would like to paint all of them." There is no question that he was a master of flower pieces. The garden of his country house had provided material for many an earlier painting, but in the last years of his life—years plagued by a sickness that would become fatal in 1883—his inspiration derived primarily from the many bouquets of flowers brought to his studio by friends. This tiny painting projects the vivid freshness of the blossoms, and its concise yet firm brush strokes suggest the speed with which Manet generally executed his still lifes. Looking at the work, and remembering Manet's words, one has the impression that the flower pieces afforded a kind of creative relaxation from the more arduous paintings with which he continually bombarded the French art establishment's Salon.

Ailsa Mellon Bruce Collection
12⅞ × 9⅝ in (32.6 × 24.3 cm)

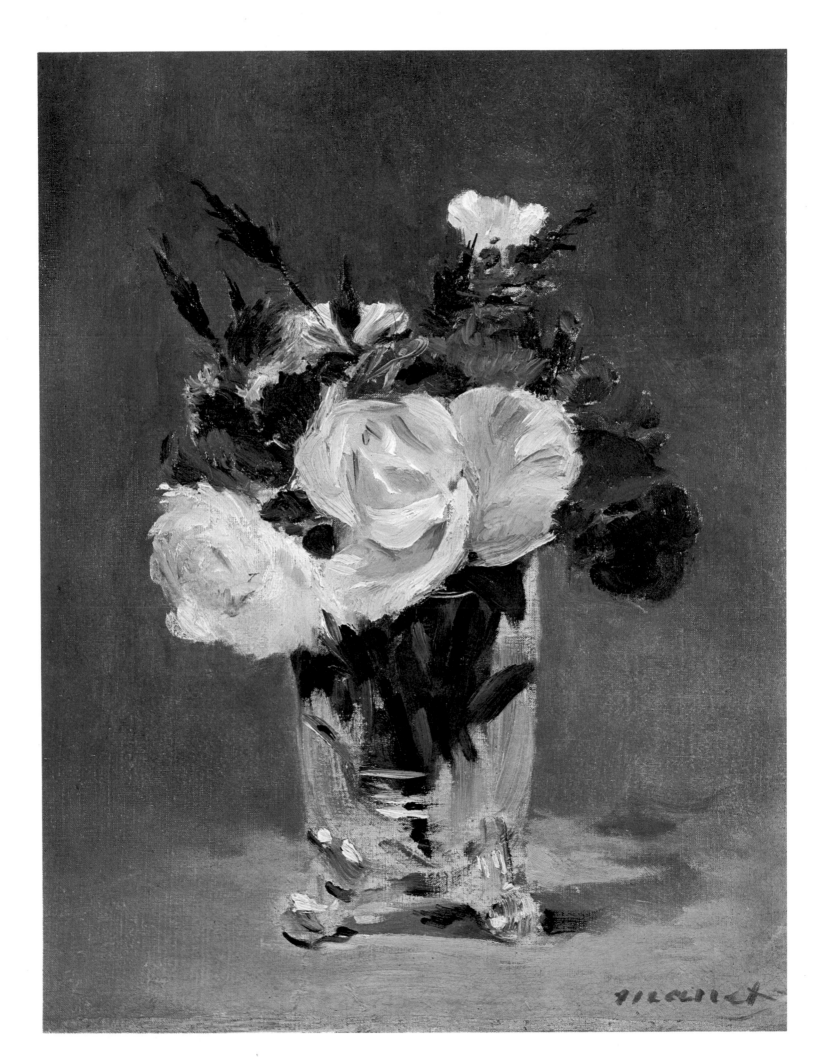

Édouard Manet

THE PLUM

(c. 1877)

THE POET AND ART CRITIC Charles Baudelaire had been the first to speak about the "heroism of modern life" and to exhort painters to seek " . . . private subjects . . . the pageant of fashionable life and the thousands of floating existences—criminals and kept women—which drift about in the underworld of a great city."

Manet had painted both the high and low life of Paris in some startling subjects of the Sixties, but toward the end of the 1870s he did a number of paintings that addressed specific aspects of Parisian life. *The Plum* depicts a nameless young woman whom Manet probably encountered at the café he and his friends frequented; it suggests that quality of detachment and ennui so often found in the waiting rooms of train stations or in popular eating and drinking places in large urban centers. Manet's composition is compact, and there is little inclination to narrative or psychological interpretation. The dextrous brushwork defines the bonnet, the woman's dress and the decorative complexities of a green screen that Manet has placed behind her head as both a foil and a frame. Every detail in the picture, from the plum in the glass cup that gives the composition its title and its key color to the placement of differently textured rectangular shapes such as the table-top, the paneling and the gilded frame, reiterates the painter's concern with the canvas's shape and calls attention to its two-dimensionality. The resonant, carefully selected tones speak eloquently for Manet's gifts as a colorist.

Collection of Mr. and Mrs. Paul Mellon

29 × 19¾ in (73.6 × 50.2 cm)

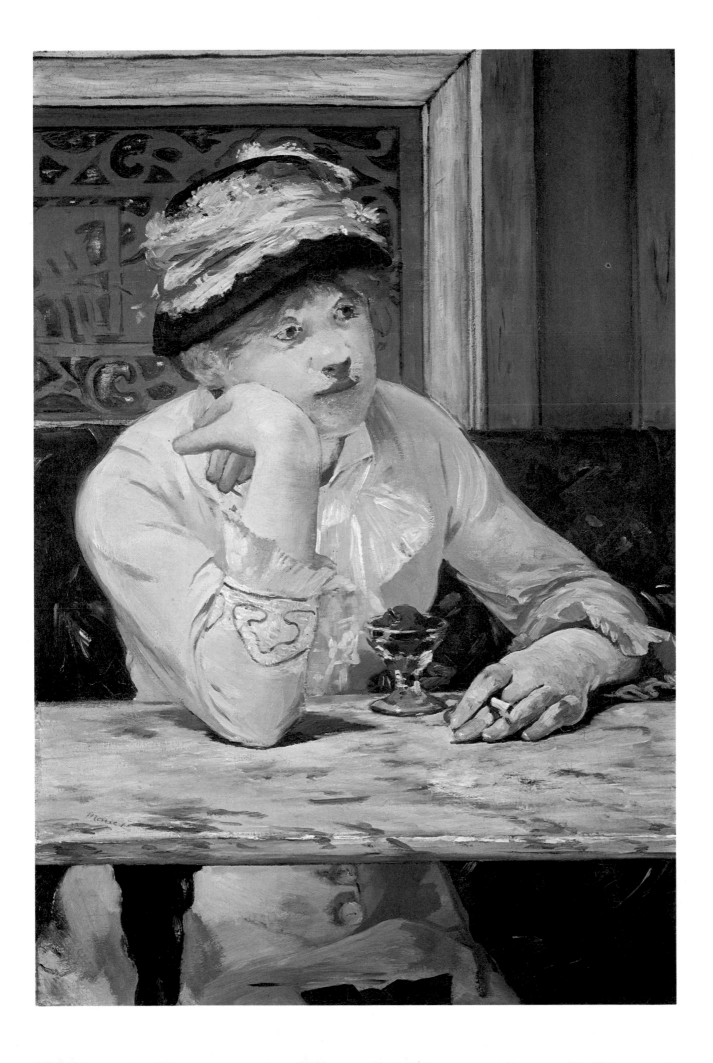

Édouard Manet

GARE SAINT-LAZARE

(1873)

PAINTED JUST ONE YEAR PRIOR to the first Impressionist exhibition, this marvelously fresh Parisian vignette was submitted to the Salon of 1874 rather than to the history-making show of the artistic rebels. Although he was a close friend of Degas, Berthe Morisot, Monet and many other artists who exhibited on that occasion, Manet never joined the Impressionists but continued to seek official acceptance. In spite of sharp criticism or outright rejection by Salon juries, Manet persisted in his efforts to bring his work before the public. He believed that only through prolonged exposure would they come to accept the new artistic concepts embodied in paintings like the *Gare Saint-Lazare* (or *Le Chemin de Fer*, as the artist originally called it).

In this composition Manet has captured the essence of a moment in contemporary life. The subject is neither historically nor dramatically significant; indeed its commonplace quality is precisely what renders it so strikingly modern. It seems that the painter's studio was close to a railway bridge and that he was fascinated by trains, which he saw as expressive of the excitement of his time. The seated woman and the young girl, linked forever in Manet's work, were not even related. The "mother" was Victorine Meurand, who had posed for Manet's scandalous masterpiece *Olympia*, and the child was the daughter of an artist friend. The combination of the young woman who gazes at the viewer and the child with her back turned away creates a delicate visual and psychological balance that reminds one of an old photograph. Manet was master of informed composition, and his sense of two-dimensional design was indeed stimulated by photography, with its harsh outlines and fixed objects. But he also drew inspiration from Japanese woodcuts, with their vigorous color contrasts and linear rhythms. This last element is particularly evident in the treatment of the fence, with its insistent, repetitive accents and its tendency to break up the space into even compartments.

While the painting continues a trend toward the representation of Parisian scenes that he had begun in the Sixties, the brighter palette and more summary handling of the paint remind us that Manet's style did respond to the challenge of Impressionism even to the point of executing more typically outdoor subjects.

Gift of Horace Havemeyer in memory of his mother, Louisine W. Havemeyer

36¾ × 45⅛ in (93.3 × 114.5 cm)

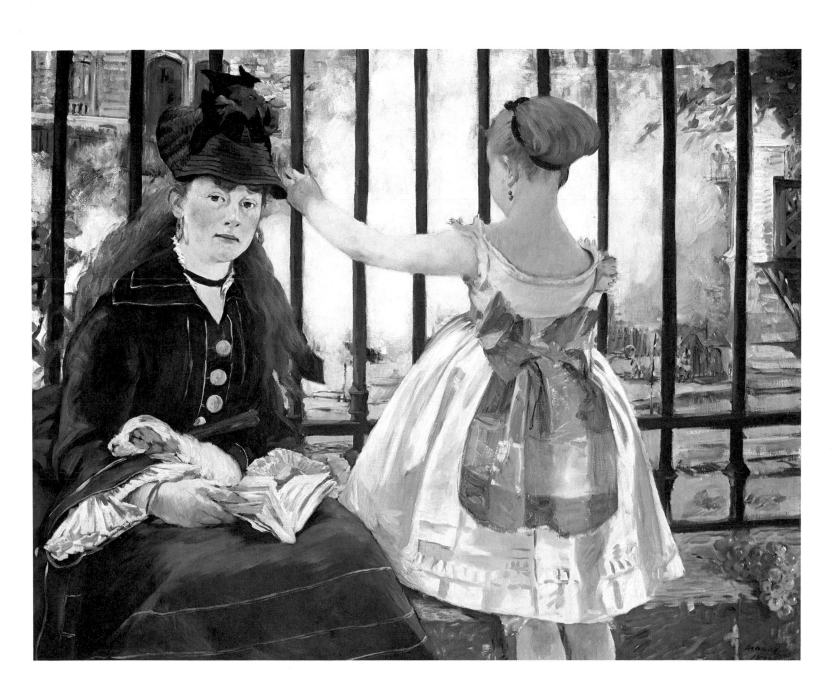

Édouard Manet

LE BAL DE L'OPÉRA
(1873)

THIS PAINTING WAS SUBMITTED to the Salon of 1874 along with *Gare Saint-Lazare* and two other works, but the conservative jury rejected it. The foyer of the opera house is crowded with women in fancy clothes and masks and their companions in evening dress and top hats. According to the critic Théodore Duret, who was a model for the painting, Manet took great pains to recreate the sense of variety and the incidental present in the original visual experience. "He carried so far his desire to capture the lifelike quality, to lose nothing of its chic, that he varied the models, even for the actors in the background, of whom one would see only a detail of a head or shoulder." Particularly striking—because of the color contrast it offers to the largely black and white patterns of the coquettes and their gallants—is the delightful yet fragmented figure Punchinello, a *commedia dell'arte* character for whom Manet evidently had great affection, for he made him the subject of four additional works in oil, watercolor and even an ambitious color lithograph. The placement of this picturesque form at the painting's edge is a favorite device of Manet's, calling attention to the surface and reiterating the finiteness of the canvas.

Manet had developed friendships with a number of distinguished poets and novelists, but he was especially close to the Symbolist poet Stéphane Mallarmé, and it is singularly appropriate that this innovative literary figure should have been sympathetic to the painter's attempts to capture an atmospheric essence rather than simply to reproduce or describe scenes. Mallarmé was supportive also of Manet's much criticized lack of what the academicians called "finish" and correctly perceived it as part of a calculated program of creating spontaneity. He called the work an "heroic attempt to capture . . . a complete vision of contemporary life."

Lent Anonymously
23⅝ × 28¾ in (60 × 73.2 cm)

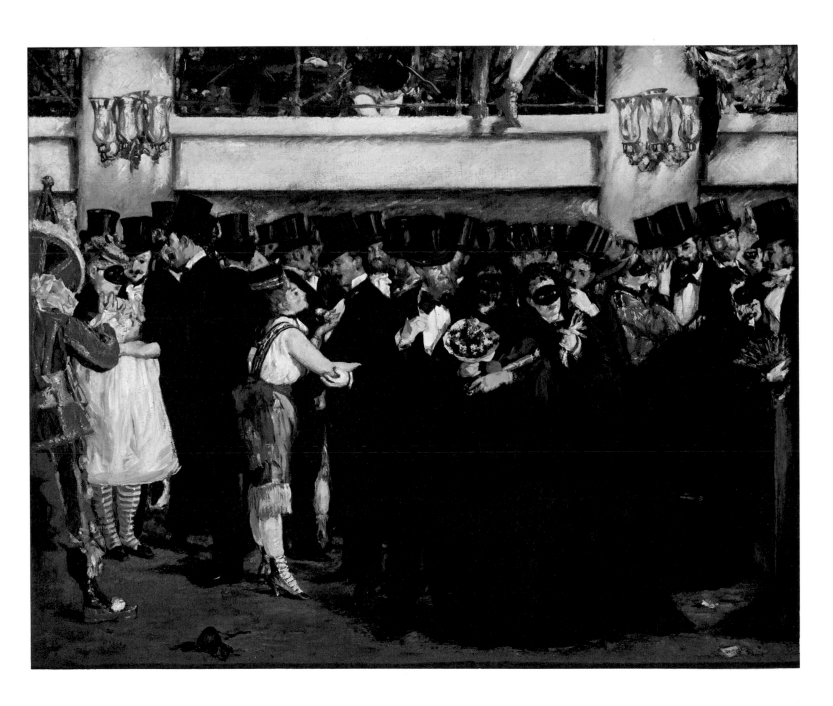

Berthe Morisot (1841–1895)

THE MOTHER AND SISTER OF THE ARTIST
(1869–70)

During the middle of the nineteenth century the Parisian upper middle class suddenly produced several important painters. That the sons of wealthy and prominent families like those of Édouard Manet or Edgar Degas chose to become painters may be surprising, but that a daughter of one did so is astonishing. Nevertheless, when the young Berthe Morisot demonstrated a talent for painting, her parents not only allowed her to study but engaged for her a distinguished teacher. While pursuing the classic student's practice of copying old masters in the Louvre, she met Manet, whose brother she would marry in 1874. Morisot was particularly responsive to Manet's bold, flat compositions inspired in part by the "Japonisme" that was affecting the sensibilities of the Impressionists, making them particularly receptive to strong silhouettes and strong color contrast. In 1870 she invited her future brother-in-law to her studio to criticize the portrait of mother and sister that had been accepted in the Salon of that year. Although he was enthusiastic about the portrait, Manet apparently couldn't resist the temptation to retouch certain areas (the eyes and mouth of the mother, her dress). The artist eventually reconciled herself to the alterations when the painting was praised in the Salon.

Paul Valéry said that Berthe Morisot lived her painting and painted her life. Her art kept step with her personal development, and her models were drawn primarily from close family and friends. The extremely personal moods of the sitters in this painting and the creation of a true ambiance invite favorable comparison with the portraits made by her friends Manet and Degas.

Chester Dale Collection
39¾ × 32¼ in (101 × 82 cm)

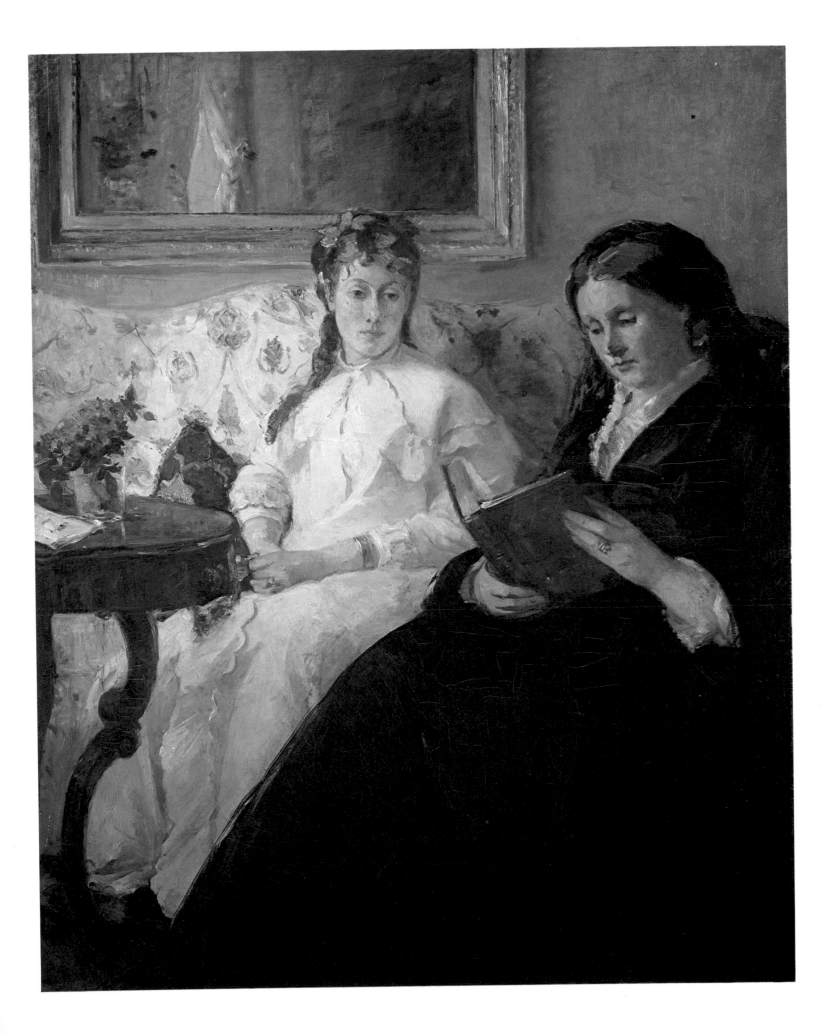

Berthe Morisot

THE HARBOR AT LORIENT
(1869)

ALTHOUGH SHE HAD EXHIBITED successfully in the official Salon, Berthe Morisot chose to enter several paintings in the exhibition organized by the Société Anonyme des Artistes, Peintres, Graveurs, Sculpteurs—dubbed Messieurs les Impressionistes by the critic Louis Leroy in his satirical review of the first show. Among the paintings exhibited by this Mademoiselle Impressioniste was the charming *The Harbor at Lorient*.

With their passionate interest in atmosphere, the Impressionists were to remain devoted to seascapes, and the Channel coast had been a favorite spot for painters since the 1860s. A casual first look at this view of Lorient, with its re-creation of one of those calm and lazy afternoons in a summer resort, belies its careful pictorial organization. Morisot has divided her canvas into even areas of predominantly bluish tones by means of the horizon line. The forms on the left are balanced by those on the right. It is the calculated introduction of the young woman with the parasol that creates the weight and just the right accent of pale yellow that rivets the viewer's eye to the right, causing the work to seem less symmetrical and, ironically, more spontaneous, as if it were some moment recorded by an itinerant photographer.

This seascape reflects Manet's influence on his close friend both in its handling of paint and in its color, but there is no question that the work already displays a delicate and refined sensibility that will become the hallmark of this gifted and charming woman's style.

Ailsa Mellon Bruce Collection

17½ × 28¾ in (44.5 × 73 cm)

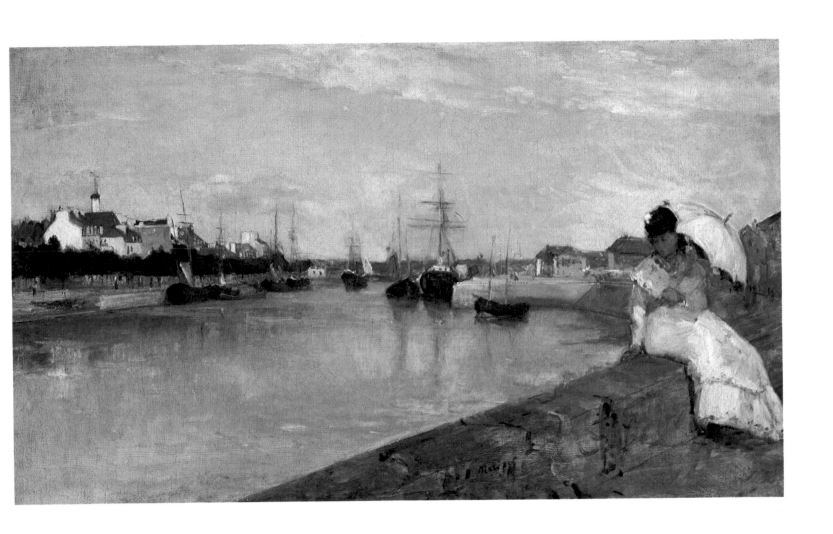

Berthe Morisot

IN THE DINING ROOM
(1886)

LOUIS LEROY WAS PARTICULARLY condescending in his references to the work exhibited by Berthe Morisot. He wrote, "Now take Miss Morisot! That young lady doesn't bother reproducing trifling details. When she has a hand to paint, she makes as many brushstrokes lengthwise as there are fingers and that's the end of it."

While her early style owed a good deal to Manet, Berthe Morisot became increasingly close to Renoir during the 1880s. The sketchily defined forms and more generous paint surface of *In the Dining Room* reveal the extent of Renoir's influence. In place of the well-defined silhouettes and strong contrasts of color reflected in the previous plates, the painter now blurs shapes and strives for an overall tonality (brown in this case). As the eye moves over the animated surface it experiences color and pigment as gesture, and it is therefore forced to acknowledge the very process of painting—something that did not occur in her more composed paintings that preceded the artist's deep commitment to Impressionism.

Chester Dale Collection

24⅛ × 19¾ in (61.3 × 50 cm)

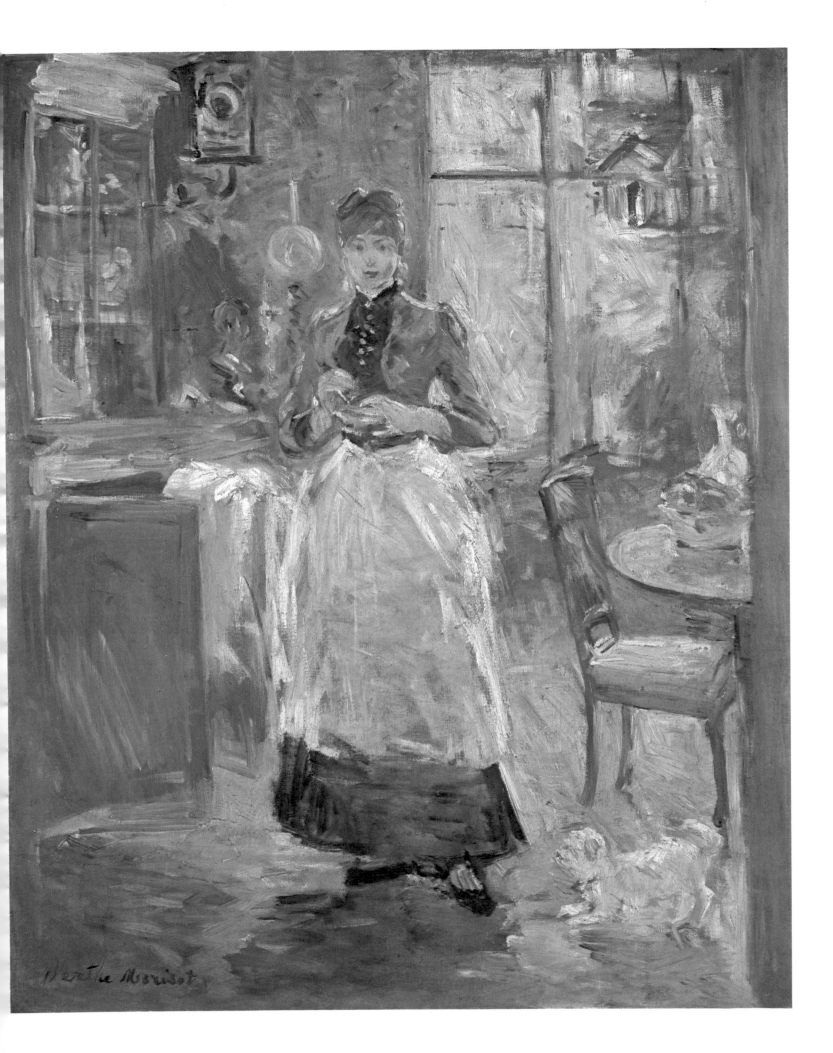

Auguste Renoir (1841–1919)

ODALISQUE
(1870)

Renoir's career was prolific, and the large body of paintings, prints and sculptures he left includes many depictions of women—tender mothers, wealthy matrons, hearty peasants and captivating seductresses. In all of these one senses Renoir's personal response to his female subjects, as one can see from this *Odalisque,* a painting exhibited in the Salon of 1870. The work affirms Renoir's admiration for Eugène Delacroix, the great Romantic painter who had popularized such exotic North African themes some forty years before. Like Delacroix, Renoir presents a languidly sensuous reclining figure whose pose and countenance are quintessentially tantalizing. The sumptuous high-keyed palette—gold, reds and blacks—testifies to Renoir's outstanding gift for decorative and evocative color. He uses color and rich paint surface as metaphors for sexuality as the textures of the delicate gossamer blouse, silken sash and embroidered pantaloons actively engage the viewer's tactile response. Moreover, everything in the painting bespeaks a frank eroticism that makes Delacroix's female love slaves seem conservative in both execution and comportment.

Théodore Duret recognized Renoir's genius for rendering women: "I doubt that a painter has ever interpreted women more seductively. Renoir's brush, light and quick, gives the suppleness, the abandon, of woman; makes the flesh transparent, colors the cheeks and the lips with a bright incarnadine. Renoir's women are sorceresses. If one came to your house, she would be the person at whom you would look first as she came in—and last as she went out."

Chester Dale Collection

27¼ × 48¼ in (69.2 × 122.6 cm)

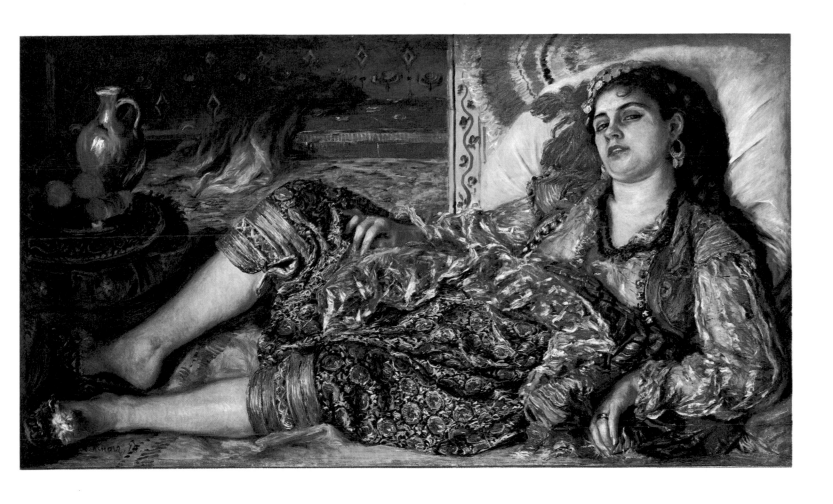

Auguste Renoir

PONT NEUF, PARIS

(1872)

ALTHOUGH HE WAS NOT BORN in Paris, Renoir had come to the capital as a young man and grown to love its marvelous wide boulevards, its parks, the river and its bridges. Like so many of the other painters in the Impressionist group, he was fascinated by the movement of urban life. When he chose to paint the Pont Neuf, he rented a room above a café that faced the bridge, and on a particularly bright day he set about the task of capturing the movement of people on foot and of horse-drawn carriages and carts. This painting projects both a sense of the broad, general view and a specific approach to the figures, many of whom are seen in characteristic attitudes—smoking cigarettes, stopping in conversation, tipping a hat, and so on, though the painter rather pointedly avoids any sense of the anecdotal. What is clearly important to Renoir and the other Impressionists who painted similar scenes is that sense of the *sweeping* view, at once capable of recording a particular incident and of synopsis.

In his *History of Impressionism* John Rewald states that Renoir's brother stopped a number of pedestrians to ask them the time of day, thus providing more time for his brother to make the quick sketches that figure so prominently in the work.

· *Ailsa Mellon Bruce Collection*

29⅝ × 36⅞ in (75.3 × 93.7 cm)

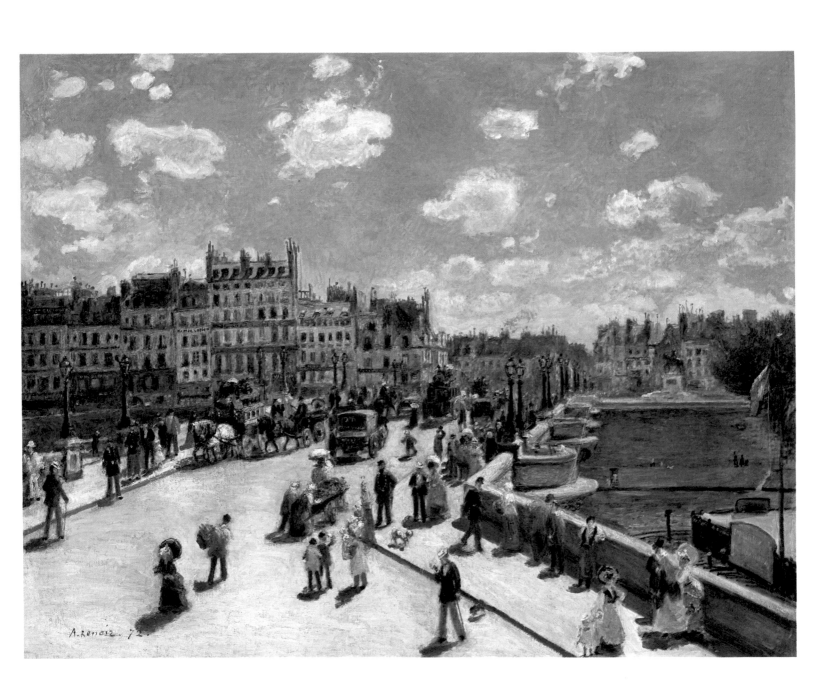

Auguste Renoir

MADAME MONET AND HER SON
(1874)

RENOIR HAD PAINTED PORTRAITS from the early years of his career not simply in order to earn a living but because he enjoyed doing them. Many of his subjects were painter friends and their families. Here he depicts Monet's fragile wife, Camille, and her young son, Jean, relaxing in the intense light of a summer afternoon.

Like his other paintings of figures in a landscape done in the early Seventies, the real subject is the effect of light on the human form. The artist emphasizes broad, virtually dehumanized forms rather than the careful, personalized portraits he would produce later. The overall surface is homogeneous as grass, feathers, clothing and skin are simply presented as slashes of pure color. Consequently, the relation of figure to ground or even figure to figure is problematic. In the process of recreating the effect of flickering light on the figures, Renoir comes close to destroying conventional formal identities. The critics who viewed this work did not appreciate this radical approach, which even Renoir later repudiated. One complained: "Try to explain to M. Renoir that a woman's torso is not a head of decomposing flesh covered with green and purple patches. . . ." While the observation relates to another painting, the problem it identifies is evident in this portrait.

Ailsa Mellon Bruce Collection
19⅞ × 26¾ in (50.4 × 68 cm)

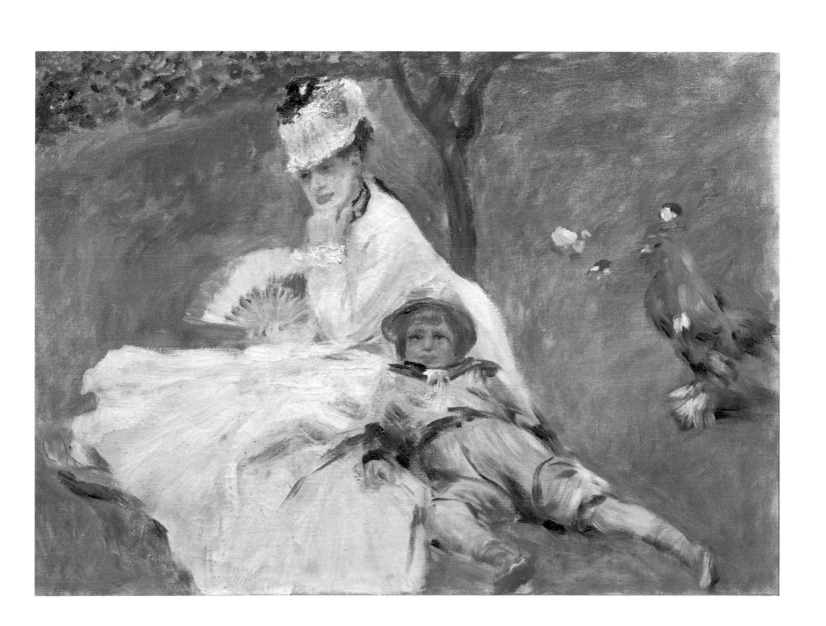

Auguste Renoir

THE DANCER
(1874)

ALTHOUGH MOST OF US ASSOCIATE ballerinas with Edgar Degas, Renoir was also attracted to the theater and to the graceful rhythms of dance. This painting was exhibited in the first Impressionist show, where it provoked Louis Leroy to observe, "What a pity . . . that the painter, who has a certain understanding of color, doesn't draw better; his dancer's legs are as cottony as the gauze of her skirts." While Leroy's criticism now may seem exaggerated—Renoir conveys the different parts of the anatomy with more clarity than the writer gave him credit for—there is no doubt that the painting poses a few problems. While Degas concentrated primarily on figures in motion, Renoir depicts the dancer in a most self-conscious pose. In his very insistence on establishing the position of the feet he imbues the dancer with a certain awkwardness that even the delicate colors and gentle brushwork do not overcome.

At this point in his career Renoir did not draw in the sense that Degas did. He relied on his brush to establish, say, the contour of the left leg and to relate it to the harmonious but arbitrary color shadows that surround it.

As a youth in Limoges, Renoir had been apprenticed to a porcelain decorator. There he copied eighteenth-century motifs such as flowers, arabesques and other decorative forms. From this experience he may have developed not only his remarkable sense of color but also his informed appreciation of artifice, a quality that ultimately would counteract the Impressionist naturalism he absorbed in the early Seventies.

Widener Collection

56⅛ × 37⅛ in (142.5 × 94.5 cm)

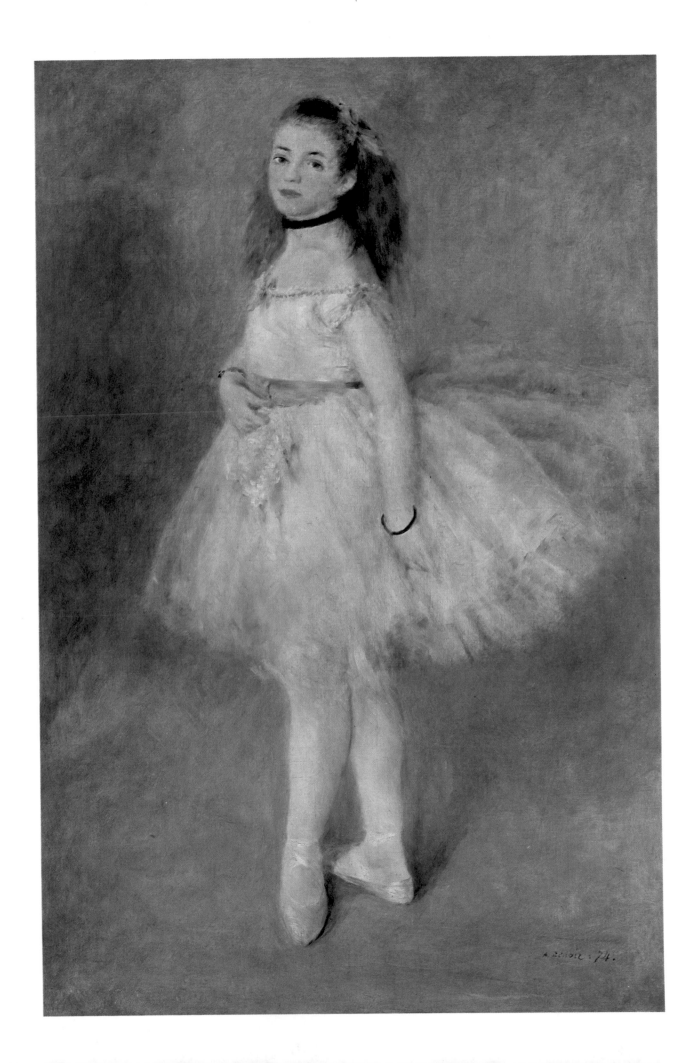

Auguste Renoir

WOMAN WITH A CAT
(c. 1875)

Renoir's demonstrable gift for painting luxurious and intimate subjects is evident in this small picture. Ten years before it was painted, Édouard Manet had shocked Paris with his *Olympia*, in which the juxtaposition of a nude courtesan and a symbolic black cat inevitably suggested both inconstancy and bad luck. Cats were often cited by poets such as Baudelaire as paradigms of sensuousness, and the animal's innate grace and personality had stimulated many other artists to verbal and visual celebrations. Renoir had great affection for animals, and he painted many a house pet. In *Woman with a Cat* the small furry creature is held as tenderly as a baby, and one feels that it is almost a surrogate for a human being. The woman's expression is wistful as she clasps the cat, prompting us to speculate whether it is not she who is seeking comfort from the animal rather than simply providing conventional affection.

Gift of Mr. and Mrs. Benjamin E. Levy

22 × 18¼ in (56 × 46.4 cm)

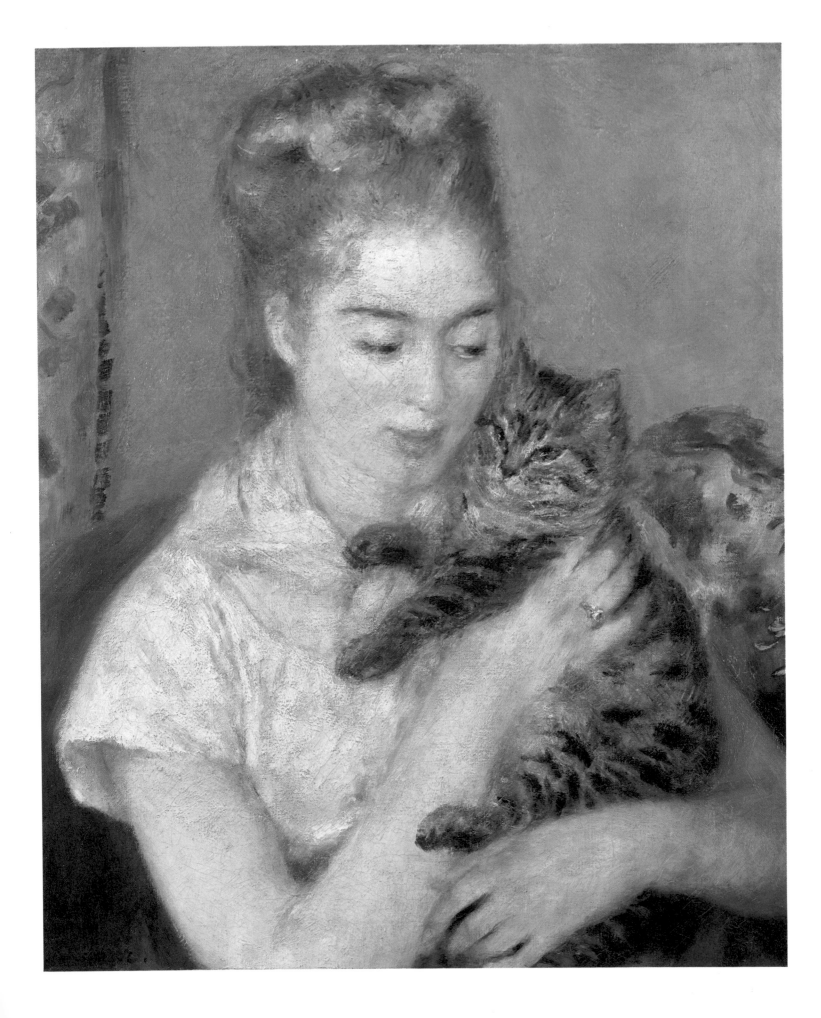

Auguste Renoir

A GIRL WITH A WATERING CAN
(1876)

ONE OF THE UNMISTAKABLE hallmarks of Renoir's painting style is the sense of exuberance and well-being that fairly radiates from his canvases. Undisputedly the most popular of the Impressionists, Renoir was charmed by children and throughout his career was particularly successful in his rendering of such delightful subjects as this unforgettable little girl who carries a small green watering can and two daisies.

We look at the child from above—suggesting the manner in which the artist first perceived her and reminding us how far the Impressionists had moved from the logical, three-dimensional space of the Renaissance. Yet unlike Manet or Degas, who often delight in confounding spatial perception, Renoir is content to stress decorative two-dimensionality, harmonizing the child with her surroundings and creating an image of warmth and radiant innocence.

The marvelous network of brightly colored, feathery brush strokes reinforces the unity of figure and landscape ground, and both seem saturated with the warm light of an early-June morning. The painter's son, Jean, recounts that his father's palette "was always as clean as a new coin." In a note made by the painter, the artist listed its basic ingredients: "Silver white, chrome yellow, Naples yellow, ocher, raw sienna, vermilion, rose lake, Veronese green, viridian, cobalt blue, ultramarine blue. Palette knife, scraper, oil, turpentine—everything necessary for painting. . . . Brushes made of marten hair; flat brushes."

Chester Dale Collection

39½ × 28¾ in (100.3 × 73.2 cm)

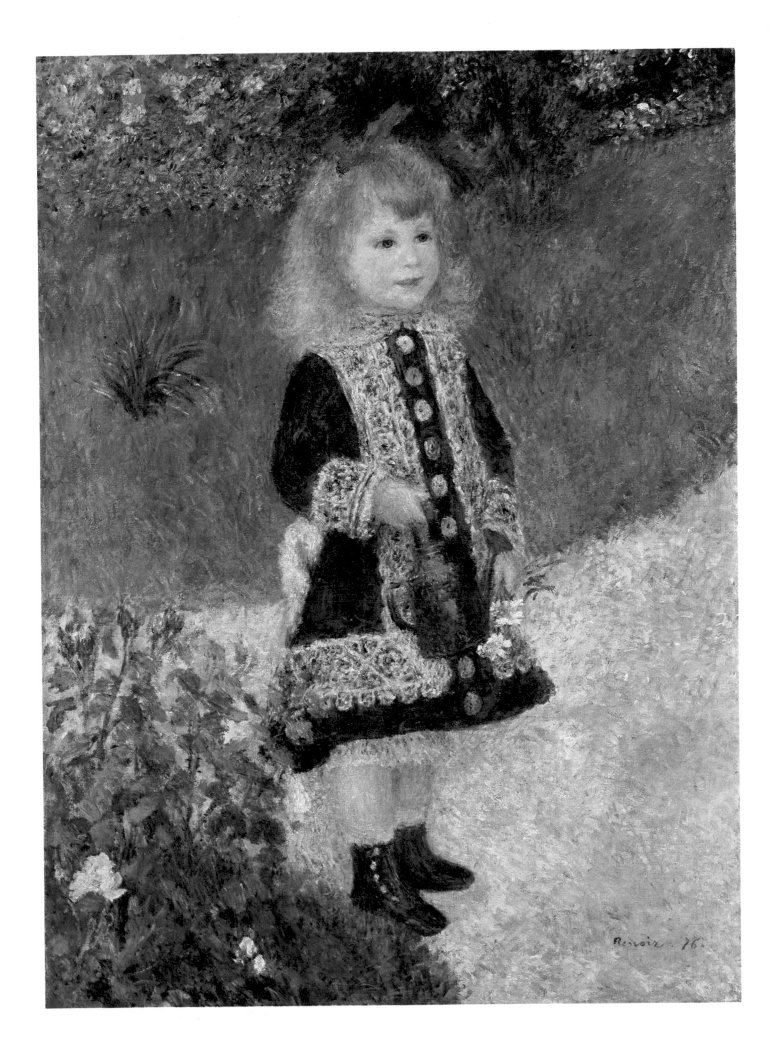

Auguste Renoir

OARSMEN AT CHATOU
(1879)

THE BANKS OF THE SEINE were dotted with spots where Parisians would swim or boat, and Chatou was among the most popular with Renoir and his friends. A subject of this sort was considered "modern" in that it conformed to Baudelaire's call for more direct involvement with contemporary life, yet it can be argued that the idea of boating and picnicking scenes also derives from the many paintings of so-called *fêtes galantes* originated in the early eighteenth century by Watteau and repeated by that artist's many imitators.

Whatever its sources, the painting reveals Renoir's continued commitment to working out of doors and his predilection for shimmering, silvery light. Yet Renoir was by no means a thoroughgoing Impressionist in the strict sense that Monet was. His figures never completely relinquish their formal integrity no matter how affected they are by the sparkling light around them. The painter constantly juxtaposes the most opulent color—in this case his favorite reds and oranges with the overall blue tones of the shimmering surface of the water.

Toward the end of the 1870s when this work was painted Renoir had begun to attract considerable attention. He earned an enviable reputation as a portrait painter—one who was especially receptive to women and children. Yet he was dissatisfied with his paintings and would shortly relinquish the broken color and immediacy of the Impressionist vision for a firmer sense of form.

Gift of Sam A. Lewisohn

32 × 39½ in (81.3 × 100.3 cm)

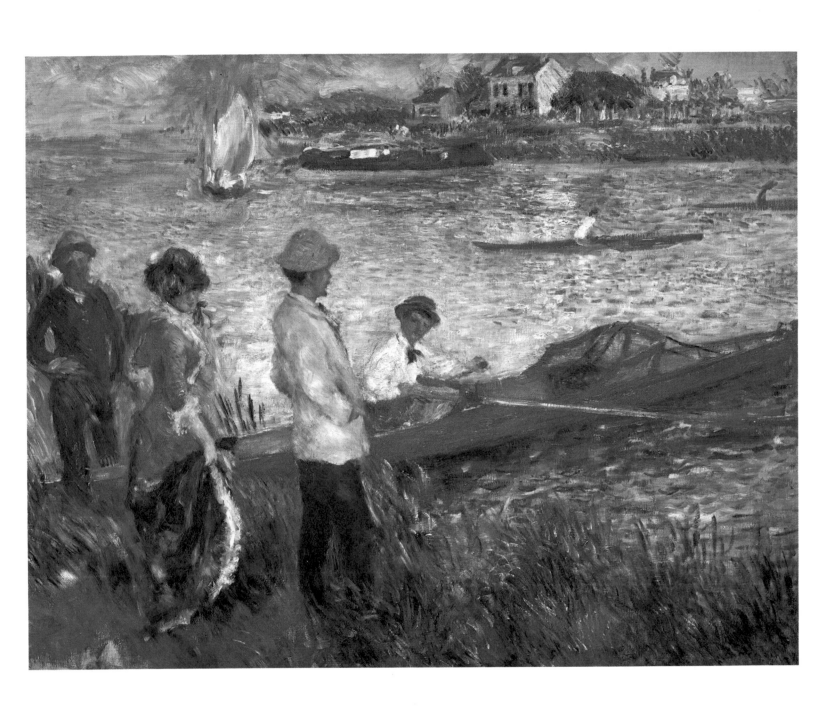

Auguste Renoir

GIRL WITH A HOOP
(1885)

In 1879 Renoir had exhibited in the Salon with considerable success. From then on he enjoyed increased patronage and, with it, financial success. He painted elegant Parisian society —the wives, children and animals of the bourgeoisie—with a singular charm that none of his Impressionist colleagues could rival. Throughout his career Renoir remained more traditional than Monet, and his particular attachment to the human figure sets him apart from the objectives of *plein-air* painting.

After his success at the Salon he wrote a letter to his dealer and defended his action: "I have just been trying to explain . . . why I send pictures to the Salon. There are 80,000 who won't buy so much as a nose from a painter who is not hung at the Salon. That's why I send in two portraits every year. . . . At this moment, I am concerned with doing good work. I want to paint stunning pictures. . . ."

The "stunning" portrait of a young girl attests to the belief that more than any other, Renoir was the painter of middle-class manners and modes. In a very candid declaration the artist acknowledged this: "I like beautiful materials, rich brocades, diamonds flashing in the light . . . and I am grateful to those who wear them, provided they allow me to paint them." While there are no diamonds flashing, the delicate brushwork and iridescent color have captured the carefree ambiance of a comfortable childhood. The smart dress, patent-leather shoes and indeed the ladylike toy tell us that this young girl will shortly take her place in the world that Marcel Proust so beautifully and nostalgically evokes in his novels.

Chester Dale Collection
49½ × 30⅛ in (125.7 × 76.6 cm)

44

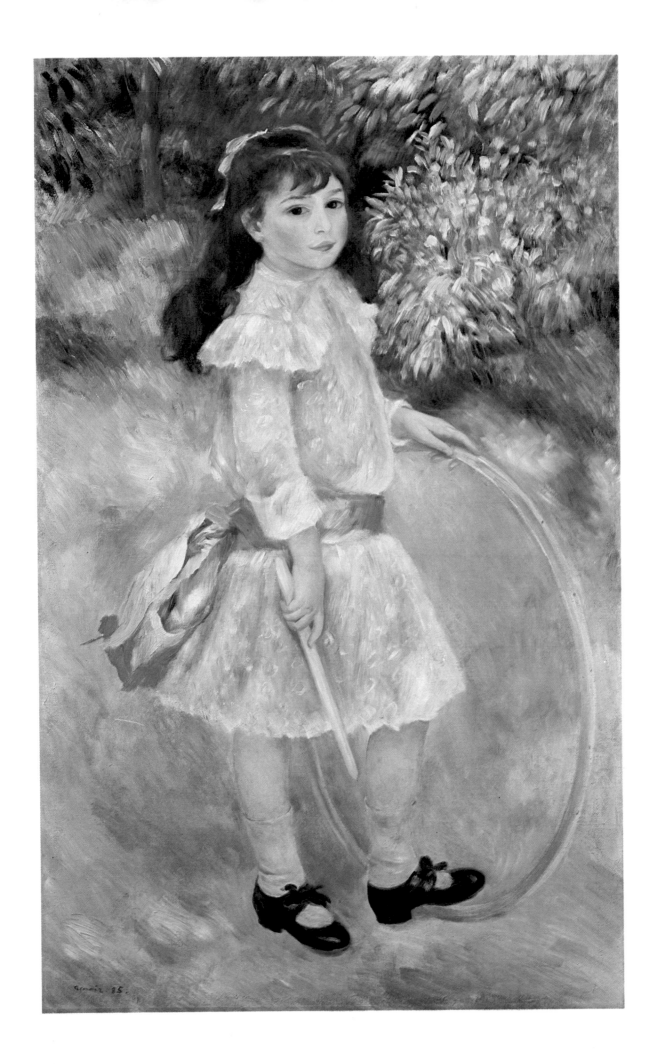

Auguste Renoir

BATHER ARRANGING HER HAIR
(1893)

DURING THE EARLY 1880s Renoir experienced a professional crisis: "I had come to the end of Impressionism and I arrived at the conclusion that I knew neither how to paint nor to draw." In fact, for three years the painter had refused to exhibit with the Impressionists. Seeking inspiration in the art of the past, he made a trip to Italy, where he fell under the spell of Raphael's Vatican frescoes and also came to admire the paintings and sculptures from Pompeii. This experience with an art of rigorous design and harmony reaffirmed his belief that the Impressionist practice of painting directly from nature had led to the dissolution of form. Returning to Paris, Renoir set out to rediscover traditional composition; in so doing, he also was reawakened to the value of more traditional subject matter. From 1884 to 1887 he worked on a large painting of bathers in a landscape setting that embodied his new concept of design. While the painting was not enthusiastically received, it signaled a major defection from the prevailing aesthetics of Impressionism that would be followed by others.

Renoir produced many variations on the bather theme. *Bather Arranging Her Hair* is less directly inspired by the art of the past than some of his work. Instead, it offers a sensuous contemporary nude whose casually discarded clothing suggests that she is engaged in a bucolic idyll. The contours of the luxurious body are firmer than in the more Impressionist style of the Seventies, but figure and background are still integrated, creating a spatially and atmospherically coherent whole. While Renoir's brush is somewhat tighter in its form when defining gestures, the role of color is still crucial.

Chester Dale Collection

36⅜ × 29⅛ in (92.2 × 73.9 cm)

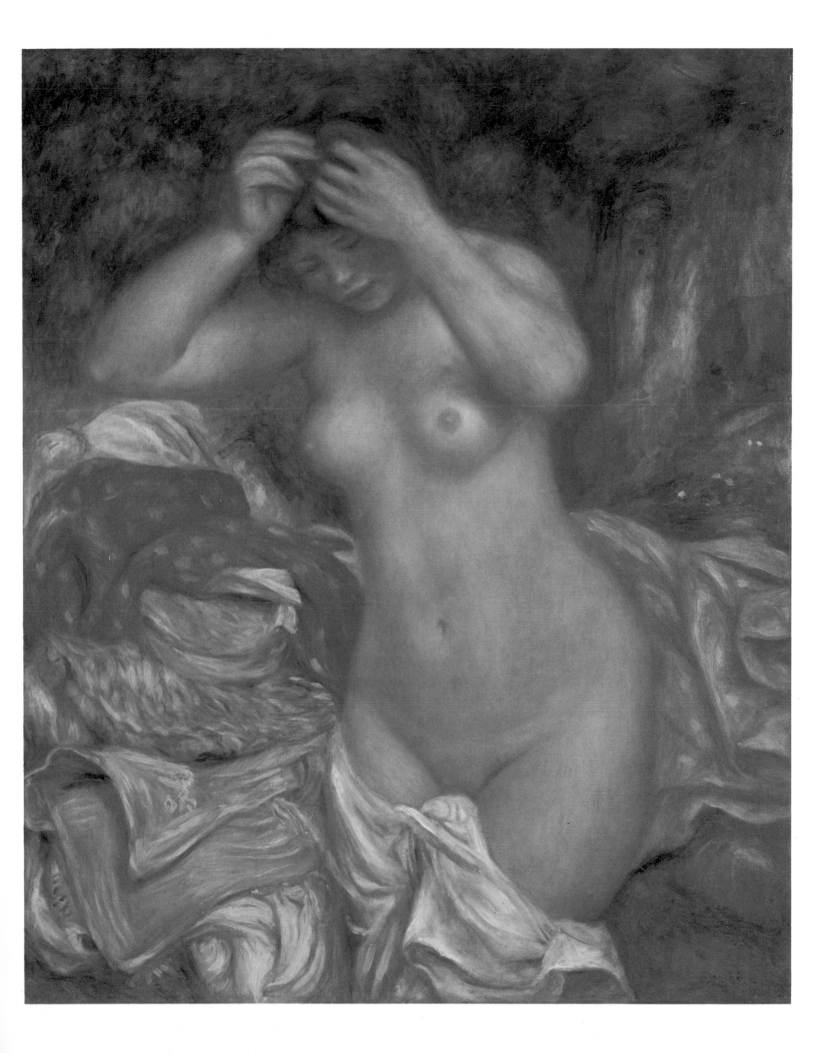

Eugène Boudin (1824–1898)

THE BEACH AT VILLERVILLE
(1864)

Born on the Channel coast, Eugène Boudin literally taught himself to paint, making such astonishing progress that he won a scholarship to study in Paris. Though his initial attraction was to landscape painting, the seacoast near his hometown of Le Havre was to become virtually his life's subject. He never tired of exploring the beaches near such fashionable resorts as Villerville, recording with evocative color and vigorous brushwork the movement of the seasonal visitors along the shore.

Boudin's dominant interest in open-air effects, especially in extremely rapid changes of light, is evidenced in this painting. Its organization is typical of Boudin's beach scenes: a longish strip of beach with a low horizon and a frieze of standing and sitting figures. Its colors capture the essense of a late summer's sunset and project the nostalgic feeling of a season already past. While conceiving a painting, the artist would make numerous sketches that often bore the date and even hour of their execution as well as some observation as to the type of day, mood, etc. He wrote, "Sometimes, during my melancholy walks, I gaze on this light that inundates the earth, that quivers on the water, that plays on clothing, and I grow faint to realize how much genius is needed to master so many difficulties. . . ."

Chester Dale Collection

18 × 30 in (45.7 × 76.3 cm)

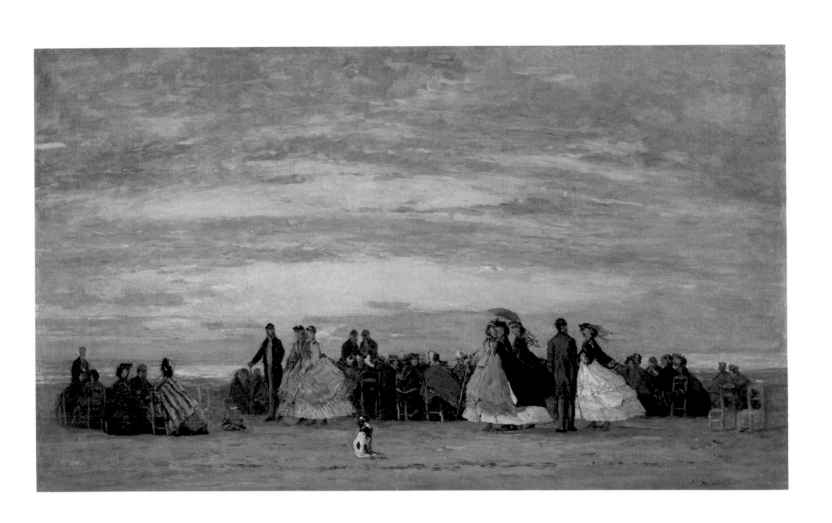

Claude Monet (1840–1926)

BAZILLE AND CAMILLE
(Study for *Déjeuner Sur l'Herbe*)
(c. 1865)

IF IMPRESSIONISM MAY BE DEFINED as an attempt to capture and reconstitute a particular visual experience; if its real subject matter is therefore the *how* as well as the *what* of seeing, then it can be argued that the grocer's son from Le Havre, Claude Monet, was the purest—indeed the quintessential—Impressionist. He alone possessed the single-minded determination to test its seemingly stringent limitations, and in the long course of his investigations he virtually redefined the concept of a painting.

Monet was first introduced to *plein-air* painting by a fellow townsman, Boudin, but he met the future Impressionists Renoir, Bazille and Sisley in Paris in 1865 and with them painted outdoors in the forest of Fontainebleau. Only two years before, Manet's *Déjeuner sur l'Herbe* had been the conversation piece of the Salon des Refusés, making him the most controversial artist in Paris, and Monet apparently was inspired both by the older painter's example and by a spirit of frank competition to paint his own entirely naturalistic version of the same theme. The enormous scale of his projected canvas (about 15×20 feet) made it impossible for Monet to paint out of doors. In the end he had to content himself with doing oil sketches such as this one of his mistress, later his wife, Camille, who posed for all the female figures, and his painter friends, notably Bazille. Later, the artist would integrate these sketches into the large composition.

No one knows when or why Monet abandoned the gigantic canvas of which only a couple of fragments survive. It was not, as originally intended, submitted to the Salon of 1866, probably because it had not been finished in time. Later it was rolled up and subsequently ruined by dampness, leaving the painter little alternative but to cut up the salvagable parts.

This sketch of Bazille and Camille for the larger painting is important not only for its intrinsic art-historical interest but also because it conveys that exceptional directness and spontaneity of pose that set Monet apart from the other painters of the Sixties.

Ailsa Mellon Bruce Collection
36⅝ × 27⅛ in (93 × 69 cm)

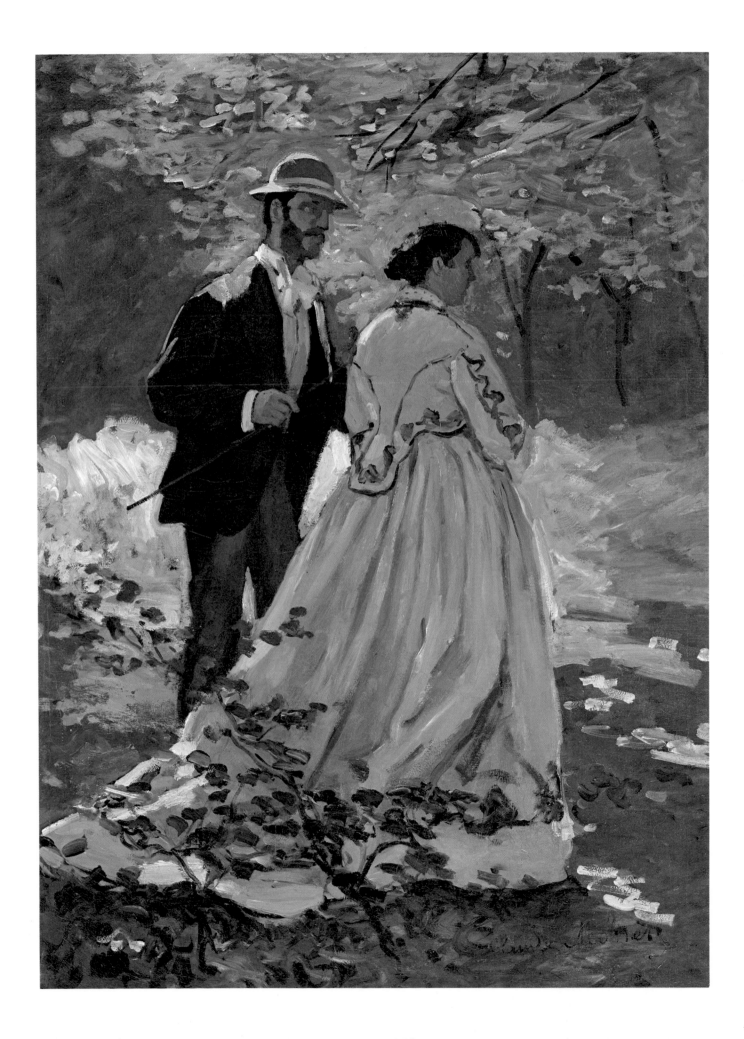

Claude Monet

SHIPS AT ANCHOR ON THE SEINE
(1872/73)

In April 1874, just ten days after the opening of the first exhibition by the *Société Anonyme des Artistes, Peintres, Graveurs, Sculpteurs,* a review appeared in a satirical journal that applied the term "Impressionist" to the works shown by Monet, Renoir, Cézanne, Sisley, Pissarro and the many others who participated. The word actually was inspired by the title of one of Monet's paintings, *Impression: Sunrise,* a seascape. For the critic who coined the term, "Impressionist" signified messiness, loose, undisciplined brushwork and resultant incoherent images that were diametrically opposed to the slick finish of the officially sanctioned painting of the salons. Actually, Monet had used the word "Impression" because he was having difficulty describing some of his canvases and because it suggested the directness and spontaneity he was pursuing.

Théodore Duret, who was unique in recognizing the import of Monet's and the others' contributions, praised them for breaking away from the dark palettes and premixed colors of the older generation: "It is to them that we owe the out-of-doors study, the sensation not merely of color, but of the slightest nuances of color . . . and still further, the search for the connection of the atmosphere which illuminates the painting and the general tonality of the objects . . . painted in it."

In *Ships at Anchor on the Seine,* Monet not only translates light and air into fresh color; he also creates excitement through the painterly components of the work rather than by resorting to literary allusion or picturesque detail.

Ailsa Mellon Bruce Collection

14⅞ × 18⅜ in (37.8 × 46.6 cm)

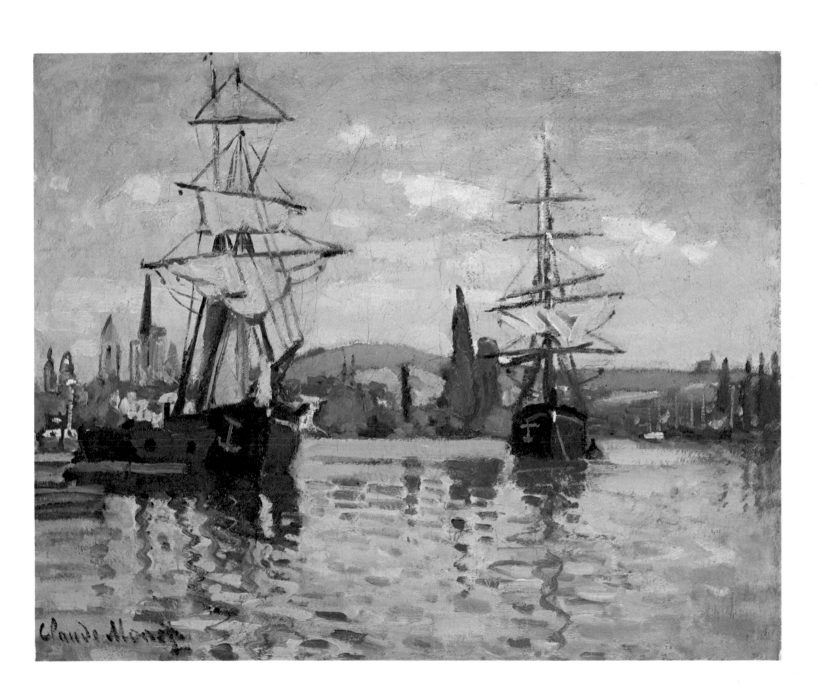

Claude Monet

THE BRIDGE AT ARGENTEUIL
(1874)

MONET SETTLED IN ARGENTEUIL on the Seine in 1872, remaining there for six years, during which time he painted the many views of river life that are among his most popular works. The painter had begun to explore the Seine and its adjoining villages in the late Sixties, depicting both workaday scenes and the life of the numerous resorts that dotted its banks. These paintings reflect the revolutionary bright palette and broken color that confounded critics and public alike at the Impressionist exhibition. In *Bridge at Argenteuil* the changing light of a highly mobile sky is translated in patches of pure color that confront the eye like pieces in a jigsaw puzzle. The composition is relatively simple: a strong horizontal band separates the realm of water from the shore and sky, while the sharp diagonal of the bridge creates an area of shadow that acts as color counterweight to the light-saturated water. The loose, individualized brush strokes serve to intensify contrasts in color and force the eye to "mix" them, thereby creating a more lively surface than those achieved in traditional color blending. Despite the fresh new vision, the painting does not display those characteristics of later Impressionism that caused some artists to desert it. Form is still rigorously defined—in the railing of the bridge, the clear outlines of sailboat—though the assault of light against the water that results in the splintering of forms augurs the coming of a period of more intense commitment to what Monet called "instantaneity."

Paul Mellon Collection
(Loan)

23¾ × 31½ in (60.3 × 80 cm)

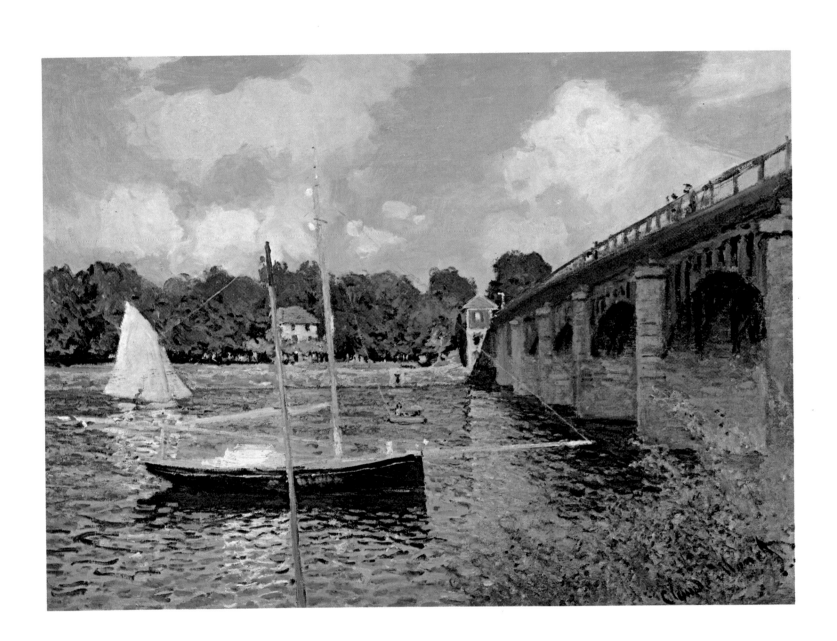

Claude Monet

WOMAN WITH A PARASOL
(Madame Monet and Her Son)
(1875)

CLAUDE MONET'S SPARKLING PICTURE captures summertime in all its scintillating brilliance. The scene is so fresh, so immediate that we feel ourselves in the field, experiencing the warm sunlight, feeling the breeze and casually observing the figures. The modishly dressed woman, wearing a veil to protect her face from the wind that whips the grasses and her skirt, is the artist's wife, Camille, while the child is their son, Jean. When Monet painted figure subjects, his models were usually family members. Yet this rendering of Camille and Jean can hardly be called portraiture because the figures literally have become part of nature, adding to the picture's evocation of bright sun and clear air.

Taking his easel into the countryside, Monet painted directly on the canvas. Customarily he indicated only major compositional lines with thin, blue strokes before applying the hues. Then he developed the drawing and painting simultaneously, for, as he once remarked, "I have never isolated drawing from color." Monet painted rapidly, not bothering to cover all the gray sizing on the canvas, which is still visible near the right and left edges. Observing that the blazing sun obscured details, dissolved forms and blurred edges, Monet employed sketchy strokes. However, he varied the brushwork to suggest movement and texture; his large, flat strokes describe passing clouds and the small, staccato dabs delineate individual grasses.

Collection of Mr. and Mrs. Paul Mellon
(Loan)

39¼ × 32 in (99.7 × 81.2 cm)

Claude Monet

BANKS OF THE SEINE, VÉTHEUIL
(1880)

THIS IS ONE OF MANY VIEWS of the village along the Seine where Monet lived. In the Seventies the painter had done a number of studies of the Seine at Argenteuil, capturing the dazzling effects of sunlight or the dull haze of fog on the water's surface. So fascinated with the reflective nature of water was Monet that he had a houseboat studio constructed that enabled him to work with even more directness. That fascination with the shimmering, volatile nature of water would remain a constant for Monet, culminating in the monumental decorative panels of water lilies that constitute his most abstract work.

Duret, who wrote more sensitively about Monet's work than any other contemporary, summed up the intention and the appeal of this painting: "The Impressionist sits on the banks of a river; depending on the condition of the sky, the angle of vision, the hour of the day, the calm or the agitation of the atmosphere, the water takes on a complete range of tones. . . . When the sky is overcast, the weather rainy, he paints glaucous, heavy opaque water. When the sky is clear, the sun bright, he paints sparkling, silvery, brilliant blue water. When there is wind, he paints the reflections produced by the ripples. . . ."

The rich contrast of color and of paint texture between the flowers in the foreground and the other parts of the painting subtly generate the viewer's awareness of the identity of pigment and create a new basis for pictorial relationships within the composition.

Chester Dale Collection

28⅞ × 39⅝ in (73.4 × 100.5 cm)

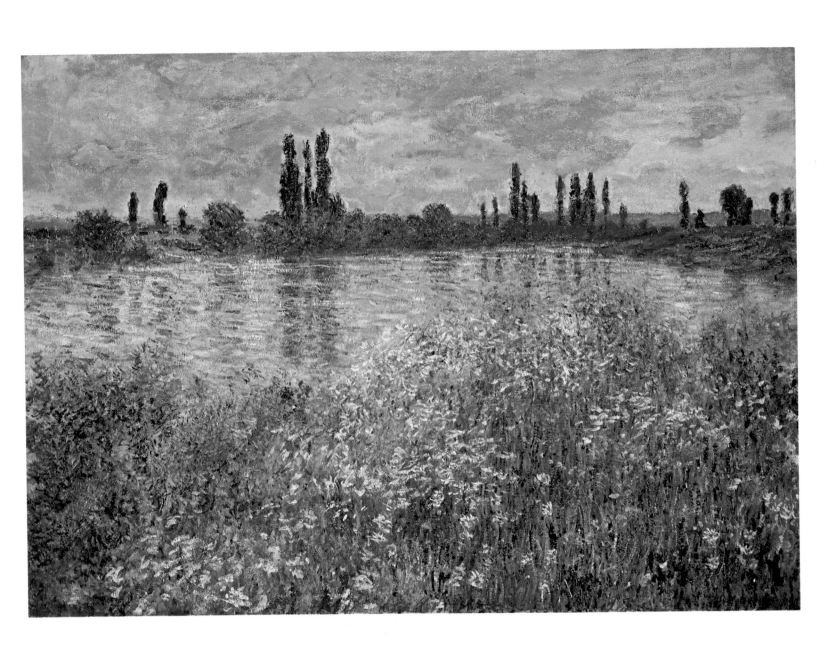

Claude Monet

THE ARTIST'S GARDEN AT VÉTHEUIL
(1880)

THIS PAINTING IS PROBABLY WHAT MOST OF US have in mind when we try to identify those qualities that are quintessentially Impressionist: a vision of dazzling light expressed in harmonies based on the reciprocal relationships that exist between colors.

In the 1880s Monet devoted more and more time to studies of light and atmosphere, pursuing that "instantaneity" that was to obsess him for the rest of his life. Carefully examining *The Artist's Garden at Vétheuil,* one soon realizes how many pure colors the artist has utilized. The vivid, broken color may suggest the intensity of the sun on the clusters of flowers or it may recreate the violet shadows of the late afternoon. If one looks at any given part of the canvas—for example, the lower right quarter—one constantly experiences the disintegration of form into flecks of red, yellow, green, blue or white. Monet worked feverishly in his effort to capture the fleeting light, and the brush strokes he used do not seem to follow regular patterns but rather suggest an impulsive and spontaneous encounter with the canvas. There is no sense that Monet consciously arranged this motif. The work seems to achieve its sense of balance, naturally, almost organically, as a result of the contrast in the density of the colors.

Later in the Eighties the dissolution of forms already evident in this painting would increase as Monet's brush became more autonomous.

Ailsa Mellon Bruce Collection
59⅝ × 47⅝ in (151.4 × 121 cm)

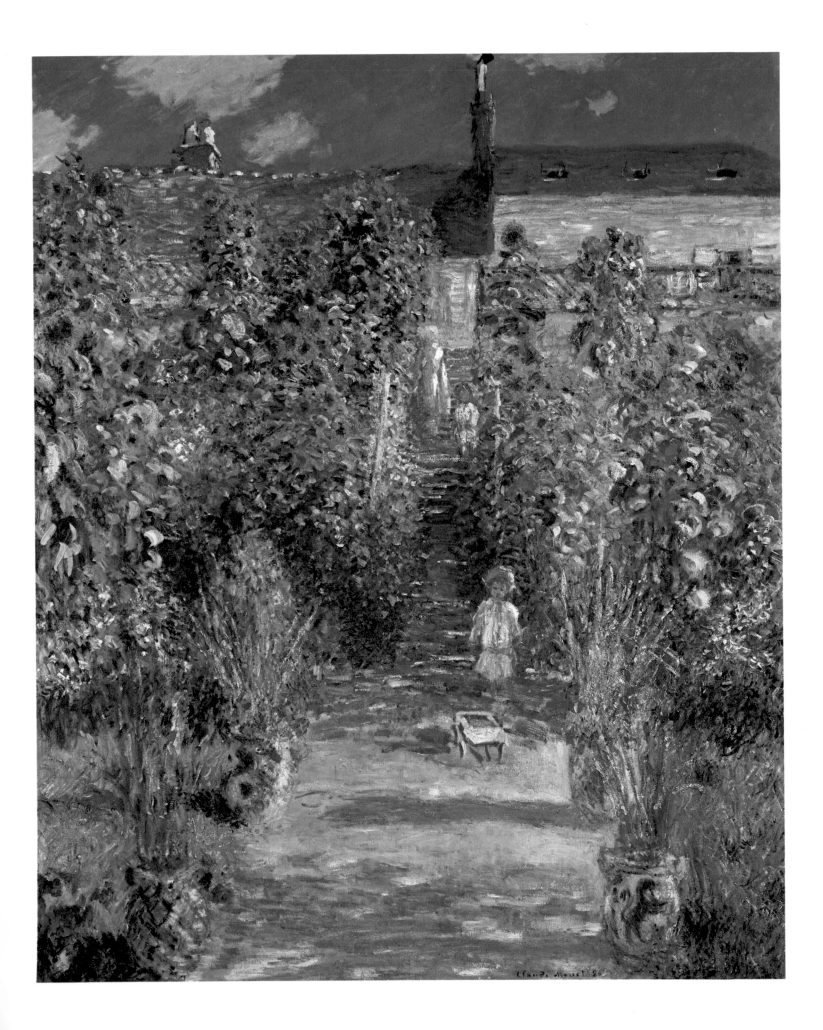

Claude Monet

VASE OF CHRYSANTHEMUMS
(1880)

Monet has painted this vase of flowers with an intensity of color and with a kind of organic vitality that makes us feel that they are fresh from his garden in Vétheuil. The quick, flickering green brush strokes dissolve into the background tones that repeat all the colors the artist used in the painting, while the deep, thick yellow of the flowers almost create the sense of relief.

The Impressionists were often accused of destroying form, but in this composition Monet has carefully preserved the formal identities of the round vase, repeating its volume in the irregular circular arrangement that frames the vase and in the shape of the table on which it rests. Though his palette is limited to red, yellow and green, the variations of tones, especially in the seemingly light-filled background, are remarkable.

Chester Dale Collection

39¼ × 28¾ in (99.6 × 73 cm)

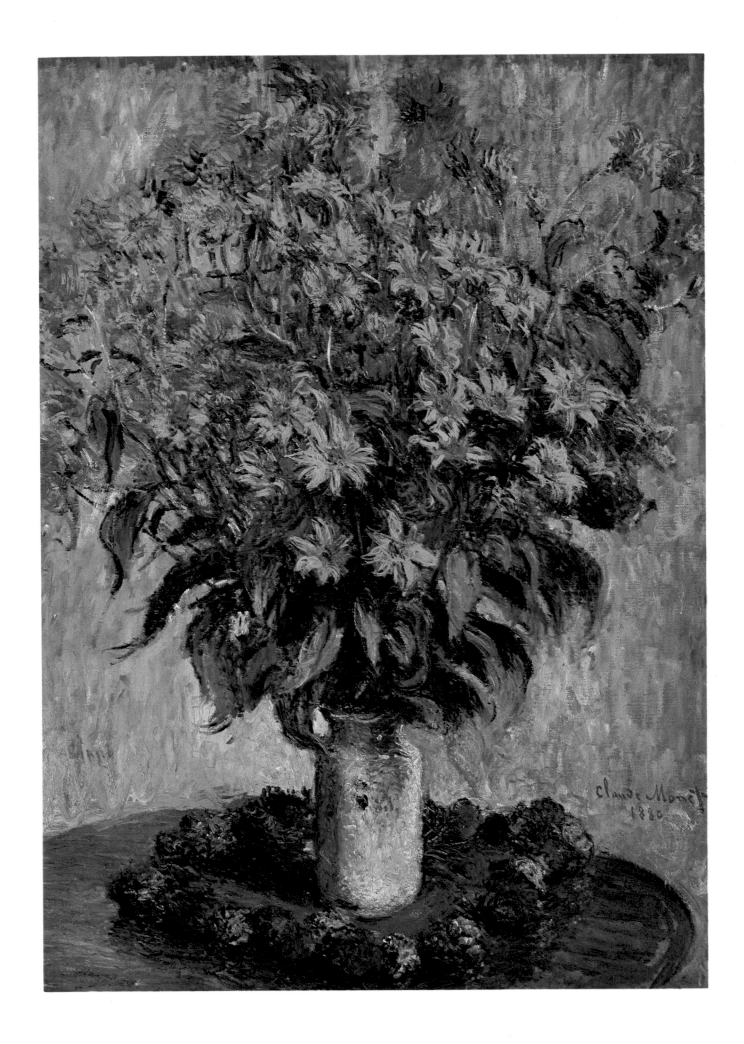

Claude Monet

WOMAN SEATED UNDER THE WILLOWS
(1880)

THIS PAINTING OFFERS ANOTHER of the rather typical Impressionist motifs, one that might in its particularly gentle poetry be compared with certain works by Corot, whom so many of the Impressionists had admired. Although Monet had done a number of figure studies of his wife in the 1860s and 1870s, he later abandoned figures for a type of pure landscape painting that would lead increasingly to abstraction. It is clear from *Woman Seated under the Willows* that the artist had no interest in the personality much less the identity of the figure. Rather he conceived the woman as simply one more object to be painted, and like the field in which she sits reading, her material presence is evoked through brush strokes that are scarcely different, except in color, from those that suggest the dense vegetation. In effect, she is seen as a part of nature and, like nature, is capable of reflecting light.

The delicate colors of the painting, predominantly lavender, yellow and green, suggest the laziness and slightly hazy light one associates with certain summer afternoons and mark the end of a period for Monet. Subsequently, he would travel a great deal—to the south of France, the Channel coast, Venice and London—in pursuit of new experiences of light. This more domestic work may have been one of the very last of its type—a slightly nostalgic pause before the revolutionary serial canvases of poplars, haystacks and cathedrals.

Chester Dale Collection

31⅞ × 23⅝ in (81.1 × 60 cm)

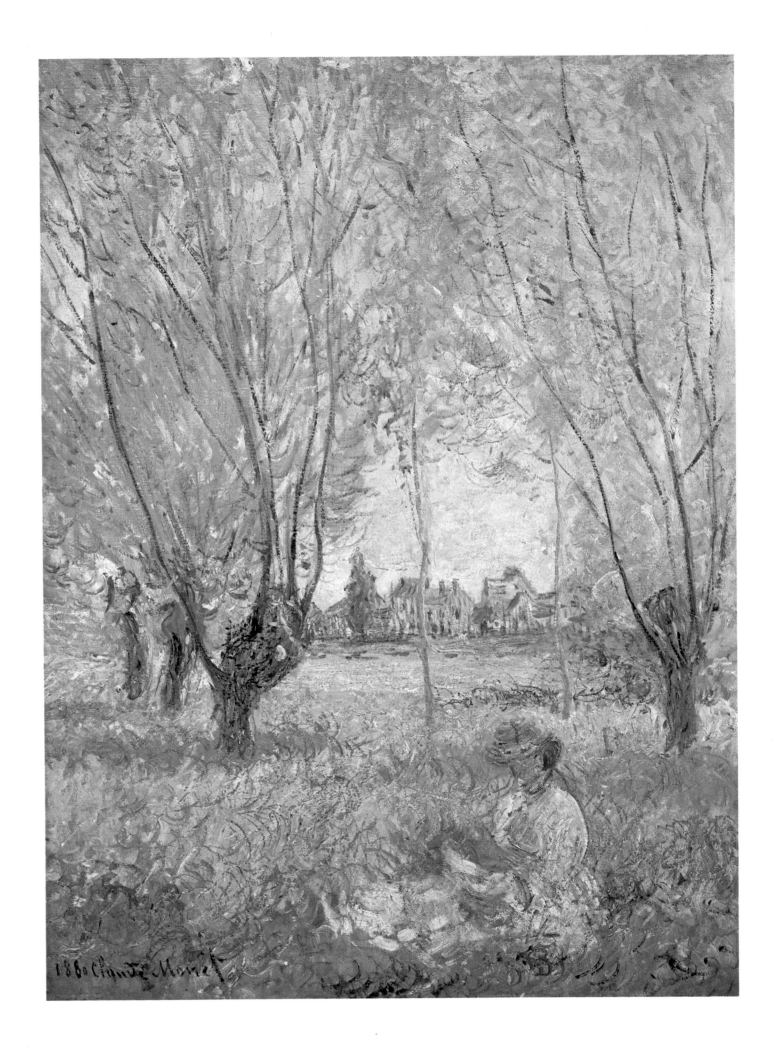

1880 Claude Monet

Claude Monet

ROUEN CATHEDRAL,
WEST FAÇADE, SUNLIGHT
(1894)

IN AN INSIGHTFUL PAMPHLET PUBLISHED in 1878, the critic Théodore Duret proclaimed that "Monet is the Impressionist par excellence," and there is no question that the work of this painter most accurately reflects the principles with which the movement has come to be identified. Monet remained loyal to Impressionism long after the defections of so many of his colleagues. The fact that in his later life Monet refused to speak of Impressionism and even denied its existence merely intensified the polemic surrounding it. Yet the reminiscences of friends and a scattering of letters written by the artist augment his paintings, providing insight into his aesthetic. To a young American painter who had met him in 1889, he stated, "When you go out to paint, try to forget what objects you have before you—a tree, a house, a field, or whatever. Merely think, here is a little square of blue, here an oblong of pink, here a streak of yellow, and paint it just as it looks to you. . . ."

Between 1892 and 1894 Monet undertook a monumental series of paintings. He executed about 40 studies of the main façade of Rouen Cathedral, a late Gothic structure whose concavities and projections made it a particularly receptive surface for atmospheric effects. In these serial paintings, done at all hours and under different conditions of weather, the subject or object lost its intrinsic meaning by virtue of the artist's obsessive preoccupation with the varieties of light effects. The sculptural bulk of the cathedral emerges as a heavy surface of colors, and the actual architectural units appear or dissolve as a result of the atmospheric conditions. It can be argued that in these works, as in so many of his paintings, Monet's true subject is light itself.

Chester Dale Collection

39½ × 26 in (100.4 × 66 cm)

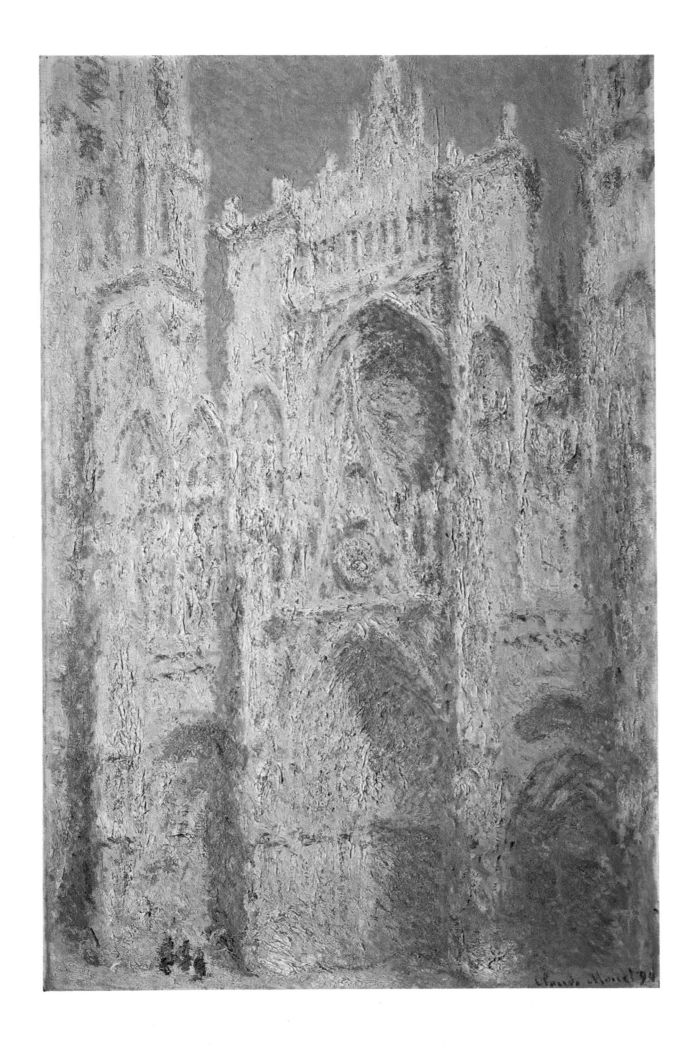

Claude Monet

PALAZZO DA MULA
(1908)

THE MAGICAL LIGHT OF VENICE has been celebrated by artists and writers for a thousand years. That Claude Monet should have been drawn to the city, its splendid churches, ornate palaces and ubiquitous canals is not surprising. What is ironic is that the painter did not see Venice until he was nearly seventy, weary in body and in spirit and suffering from an acute loss of vision.

Monet had labored for nearly a decade over the painting of his water-lily garden at Giverny. These studies of flowers floating on the surface of the pond in every condition of light and at every time of day were the logical extensions of the numerous serial paintings he had made in the 1890s. Yet the contemplative and decorative intention of these almost abstract paintings and of the twenty-nine canvases that resulted from his stay in Venice is so different from Monet's earlier Impressionism that it forces us to question the relevance of the term for the painter's late work.

Monet was so delighted with the "unusual light" of Venice that he remained in the city for four months and even returned the following year. He brought back to France paintings that he subsequently elaborated in his studio, thus departing from that direct, spontaneous method of painting that he had practiced earlier. Confronting the dazzling architectural variety of the city, he selected a group of palaces and confined himself to studies of their canal façades. The results can be characterized as variations on a theme in that the individual architectural features are subordinated to the artist's concern with re-creating the light-dissolved surfaces of the buildings. For Monet, the façade of Palazzo da Mula is a shimmering curtain of resonant blues, evanescent greens and flickering reds that serve as a decorative if somewhat melancholy metaphor for the city suspended as it is between sky and water.

Chester Dale Collection
24½ × 31⅞ in (62 × 81.1 cm)

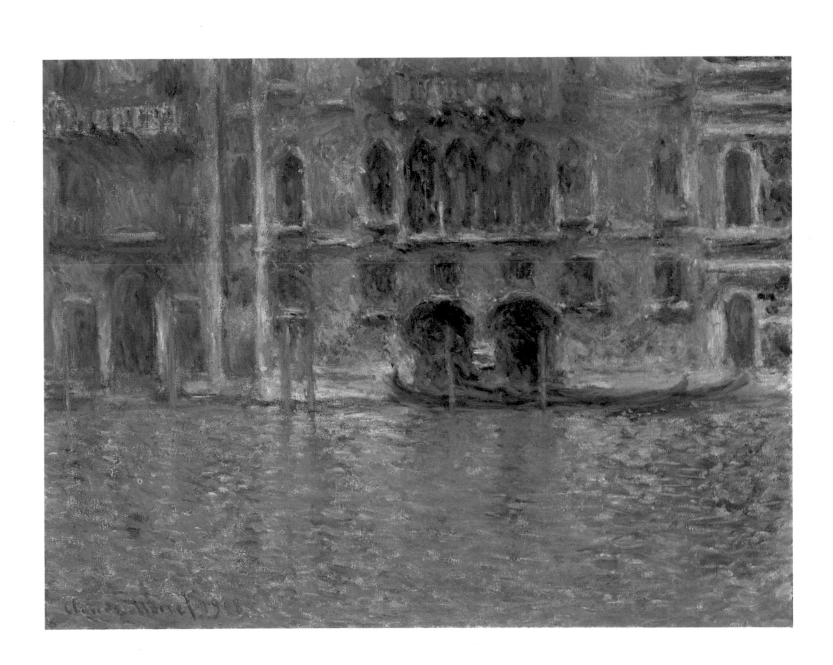

Edgar Degas (1834–1917)

ACHILLE DE GAS IN
THE UNIFORM OF A CADET
(1856–57)

LOOKING AT MANY OF THE paintings of Edgar Degas, we may wonder whether it is proper even to consider him an Impressionist. His close association with the group did not really shape his art; he was, in reality, an outsider who placed great value on his independence. By birth an aristocrat, he had more in common with Manet than with any of the Impressionists, who came for the most part from modest social and economic backgrounds. He also differed from them in temperament and artistic inclination. He particularly revered the work of Ingres, the master draftsman of Neoclassicism and one of the finest portraitists in the history of French painting. Degas studied with a pupil of Ingres, and the many drawings that he did as a young man reveal that he had taken to heart the master's advice, "Draw lines, young man, plenty of lines." That sure sense of formal structure developed early in his career later provided the basis for both subtle development and radical experimentation.

Before leaving on a trip to Italy that would bring him into direct contact with early Renaissance painting, whose strong linear values and decorative two-dimensionality fascinated him, the twenty-two-year-old student made this portrait of his older brother. The relatively austere colors, simple background and clear-cut silhouette of the young officer-to-be may remind us of sixteenth-century Florentine portraits of youthful, somewhat indolent aristocrats, but the portrait also merits comparison with those of Ingres. Degas collected the work of this great artist and even made notes on several of his portraits.

In its sure sense of form and subtle color, the portrait shows an artistic promise that was to be fulfilled in his more mature works of the next two decades.

Chester Dale Collection
25⅜ × 20⅛ in (64.5 × 46.2 cm)

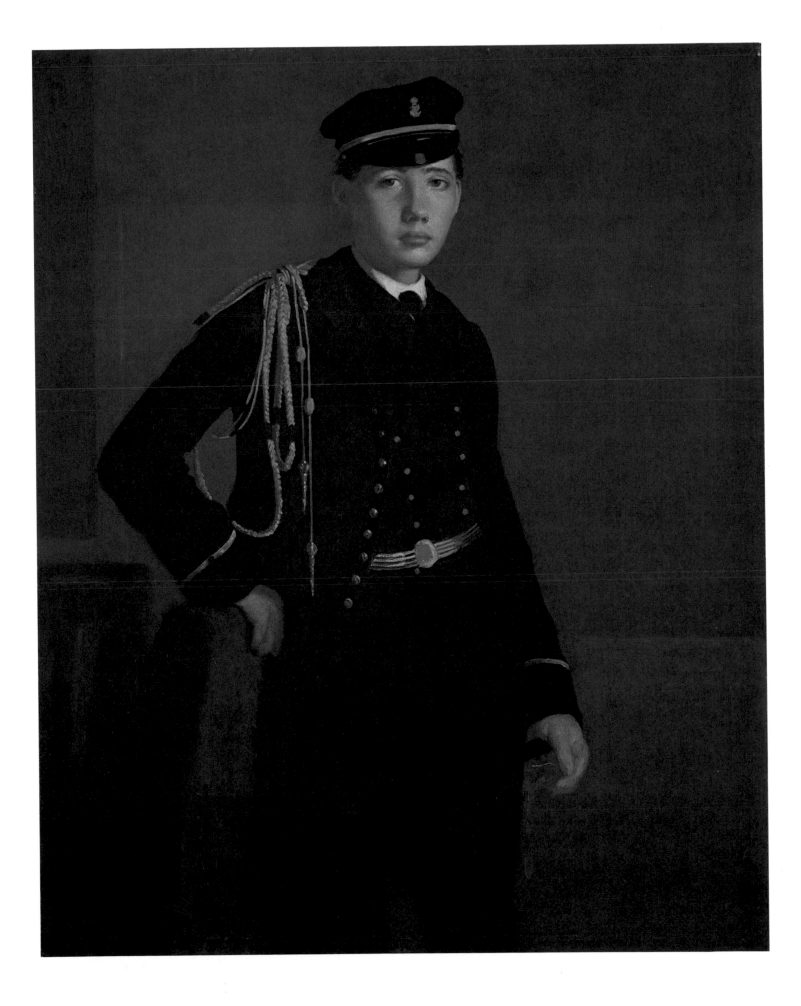

Edgar Degas

EDMONDO AND THÉRÈSE MORBILLI
(c. 1865)

DEGAS' SISTER, THÉRÈSE, HAD married Edmondo Morbilli, a Neapolitan aristocrat, two years before this portrait was done. The artist has chosen to combine rigidly formal elements with informal ones (the contrasting poses of the man and woman) and highly detailed or finished areas (Edmondo, the doorway and wallpaper) with unfinished ones (Thérèse's dress and the vaguely defined forms adjacent to her). The summary treatment of Thérèse is also curious and provokes speculation about the artist's intentions. What was the object he seems to have left unfinished on her lap? Why did he leave the painting in this condition? In contrast to the sketchy treatment of Thérèse's dress, the woman's oval face and particularly her large dark eyes are clearly accentuated. She seems rather awkward, whereas her husband's insouciant pose and even gaze suggest the cool ease of the born aristocrat.

Some of the flatness of design that marks this portrait may be derived from the study of early photographs. Degas not only looked at photographs but was an amateur photographer. He often seems to mimic photographs with their arbitrarily sharp outlines or accidental blurs. The dark colors he uses in this painting further underline its two-dimensional quality, and the influence of Japanese woodcuts with their inclusion of casual, cut-off figures is evident in the introduction of figures who are seen as chalky silhouettes in a room beyond Edmondo. This introduction of inferentially related figures not only serves to amplify any spatial ambiguities inherent in the composition but contributes to its uncertain ambiance as well.

Chester Dale Collection

46⅛ × 35⅜ in (117.1 × 89.9 cm)

Edgar Degas

MADAME CAMUS
(1869/70)

THIS PORTRAIT, the second of the sitter done by Degas, was exhibited in the Salon of 1870. Five years before, Degas had met Édouard Manet and his wife and within a short time had become a member of their social world—a world populated by upper-middle-class sophisticates like Madame Camus, the wife of a distinguished physician and an accomplished amateur musician.

A superficial consideration of the work might lead the viewer to conclude that it is merely a study in reds in which neither the physicality nor the personality of the sitter emerges. It can be argued that Mdame Camus is presented as democratically as the other objects in the composition. In fact, when the portrait was shown, Degas' friend, the critic Duranty, complained that he had subordinated the sitter to the painting of the wall, and there is no question that the shadowy profile of the woman hardly conforms to the conventions of traditional portraiture. Actually, in the process of painting this and other portraits, Degas was literally redefining the nature of portraiture. His sensitive attention to such details as the position of the sitter and her relation to the total pictorial space (Madame Camus leans forward in her chair as if listening to music) and his selection of a limited but significant group of objects (fan, sculpture, gilt-framed mirror) serve to define an ambiance that is warm, cultivated and intense. The hazy light of a flickering gas lamp accounts for the slightly blurred forms and for the sense of intimacy that characterizes the portrait.

Duranty, who had criticized this work, subsequently came to appreciate Degas' unorthodox approach to portraiture. In a brochure called *The New Painting,* written in conjunction with the Impressionists' exhibition of 1876, he exhorted painters to emphasize ". . . the particular note of the modern individual, in his clothing, in the midst of his social habits, at home or in the street. . . ." Clearly, the inspiration for these lines was Degas.

Chester Dale Collection

28⅝ × 36¼ in (72.7 × 92.1 cm)

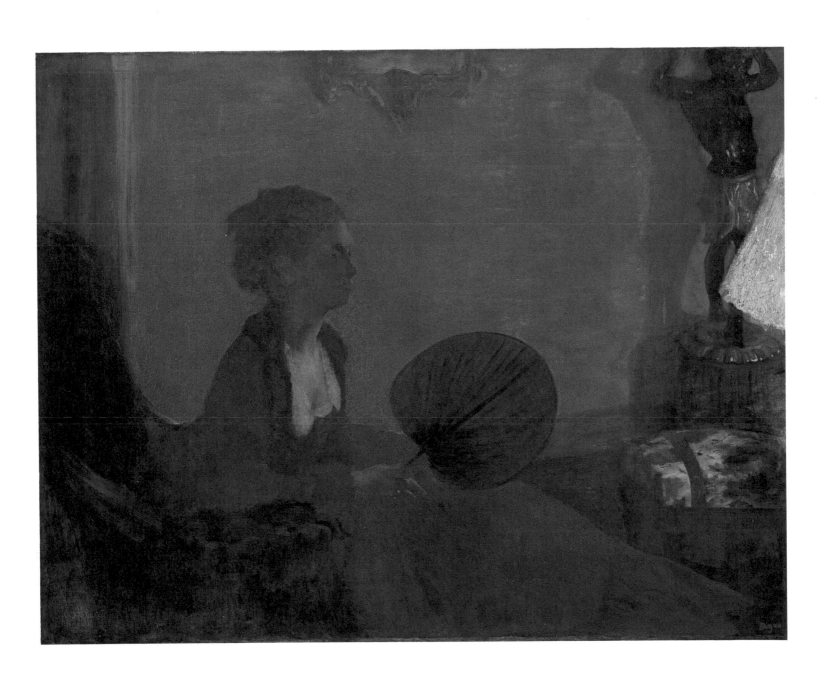

Edgar Degas

MADAME RENÉ DE GAS
(1872–73)

Degas' family was a large one. He had numerous relatives in Italy, where he visited in the 1850s and 1860s, and in 1872 his younger brother René persuaded him to make a voyage to New Orleans, where their mother had been born and where he and an older brother had entered the family's cotton brokerage business. There he undertook several portraits of his Louisiana relatives, of which this is certainly the most unusual.

Degas had been especially fond of his younger brother and seems to have found an equally warm place for his blind wife. He paints her in tones of faded rose, white and gray, gently suggesting both her blindness in the somewhat fixed expression that is illuminated by an unseen light and her dignified and resigned character. The portrait, like others by Degas, projects that quality of utter unposed "rightness." The artist had called for a fresh approach to portraiture, encouraging new vantage points and expressing the belief that a sitter's face should be related to the language of the body. We can certainly perceive not only visual but psychological coherence in this work.

Since Degas never married and since many of his paintings depict women in an unflattering light, many have speculated that he was a misogynist. Yet portraits such as this one certainly reveal the sensitive and comprehending side of this very complex individual.

Chester Dale Collection

28⅝ × 36¼ in (72.7 × 92.1 cm)

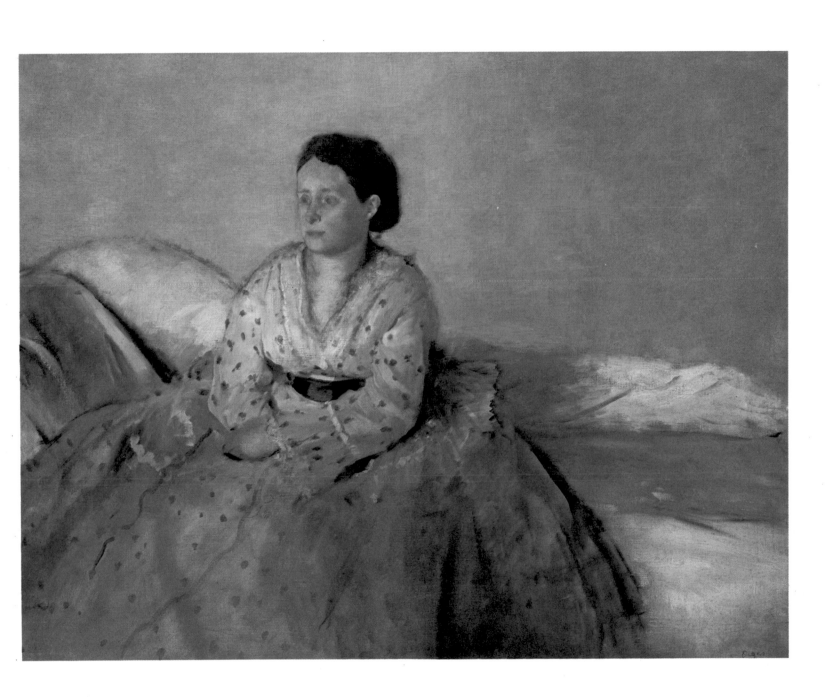

Edgar Degas

THE RACES
(c. 1873)

ALTHOUGH HE EXHIBITED in all but one of the Impressionist shows, Degas had an aversion to the term, if not the basic concepts that came to be associated with it. Indeed, he battled the very use of the word as a label for group exhibitions in the late 1870s, preferring the term Independents. Seeming to rebuke his colleagues for their passion for the immediate, Degas proclaimed, "No art was ever less spontaneous than mine. What I do is the result of reflection and study of the great masters; of inspiration, spontaneity, temperament I know nothing." Unlike the other Impressionists, he was not interested in painting outdoor scenes; they account for a small part of his vast body of works. The significant exceptions were for the most part studies of racecourses, such as this picture.

Degas seems to have been attracted to the races because of his love of horses and because of his characteristic preoccupation with anatomical movement so beautifully expressed in his countless studies of dancers. Avoiding dramatic or narrative compositions, he concentrates on either the preparation or the aftermath of an event. He was concerned with presenting the randomness of life, yet he arrived at it by a method different from the Impressionists. Degas would render numerous sketches of racing motifs and then return to the quiet of his studio to compose the various elements into a work that would then have the "accent of truth."

Degas was a collector of art, and while he had profound admiration for the great European artists of the past, he was enormously attracted to Japanese prints, particularly the landscapes of Hokusai and Hiroshige. The low, even horizon line, the simplification and flattening of forms and the limitation of colors are all indicative of the influence of Japanese woodcuts, which also would inspire him to combine different viewpoints, such as the cantering horse on the extreme right, the standing horses on the left and the intervening, diminutively scaled horses between them.

Widener Collection

10½ × 13¾ in (26.5 × 35 cm)

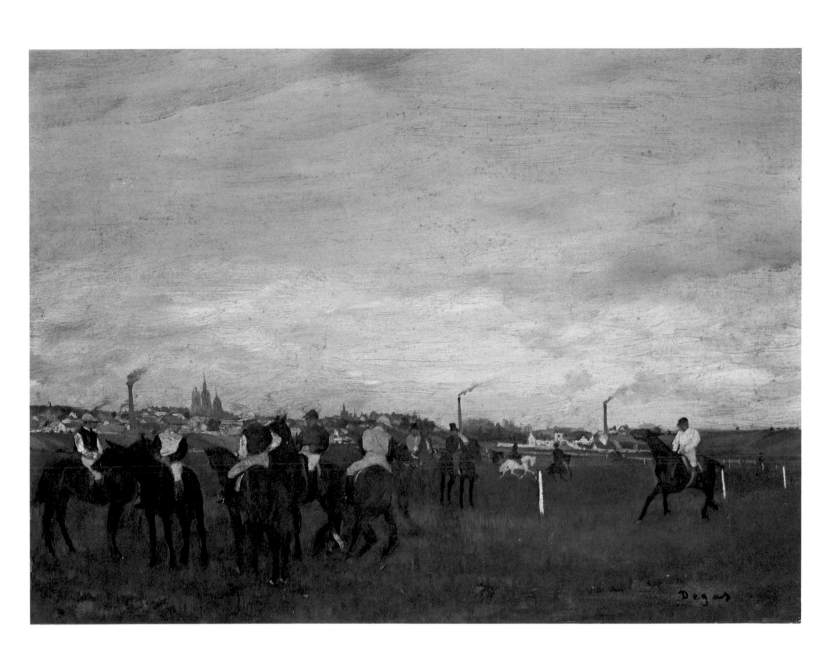

Edgar Degas

DANCERS AT THE OLD OPERA HOUSE
(c. 1877)

Aʟᴛʜᴏᴜɢʜ ʜᴇ sʜᴀʀᴇᴅ ᴛʜᴇ ɪᴍᴘʀᴇssɪᴏɴɪsᴛs' interest in subjects directly inspired by contemporary life, Degas continued to have serious reservations about both the working methods and the ultimate goal of his colleagues. While he wished to seize a particular moment and convey the spontaneity of a first impression, he also strove to impart a sense of form that, by contrast, was absent from many Impressionist works. The range of his subjects in the 1870s—cafés and their inhabitants, dance halls, racetracks and theaters—displays that magic combination of masterful drawing and exquisite color that sets his *oeuvre* apart from the mainstream of Impressionism. For Degas, *plein-air* painting was a mistake. His definition of a painting as "primarily a work of the imagination of the artist. It must never be a copy. If later you add a few touches of nature, obviously that does not harm" was the antithesis of Impressionist spontaneity.

In the 1870s, Degas painted a great many ballet scenes. In them he examined nearly every aspect of dance, from the long hours of preparation and rehearsal to the curtain calls after a performance. He was constantly searching for new motifs, and his candid but cultivated eye captured the moving forms, preserving their freshness in quick sketches that were subsequently woven into painted designs of seemingly effortless complexity or breathtaking simplicity. The ballet afforded Degas an opportunity to pursue his interest in light sources, in unusual vantage points and, about all, in a variety of shapes—the basis of his unique two-dimensional design. All of these elments make *Dancers at the Old Opera Hbuse* one of Degas' most characteristic ballet scenes.

Ailsa Mellon Bruce Collection
8⅝ × 6¾ in (21.8 × 17.1 cm)

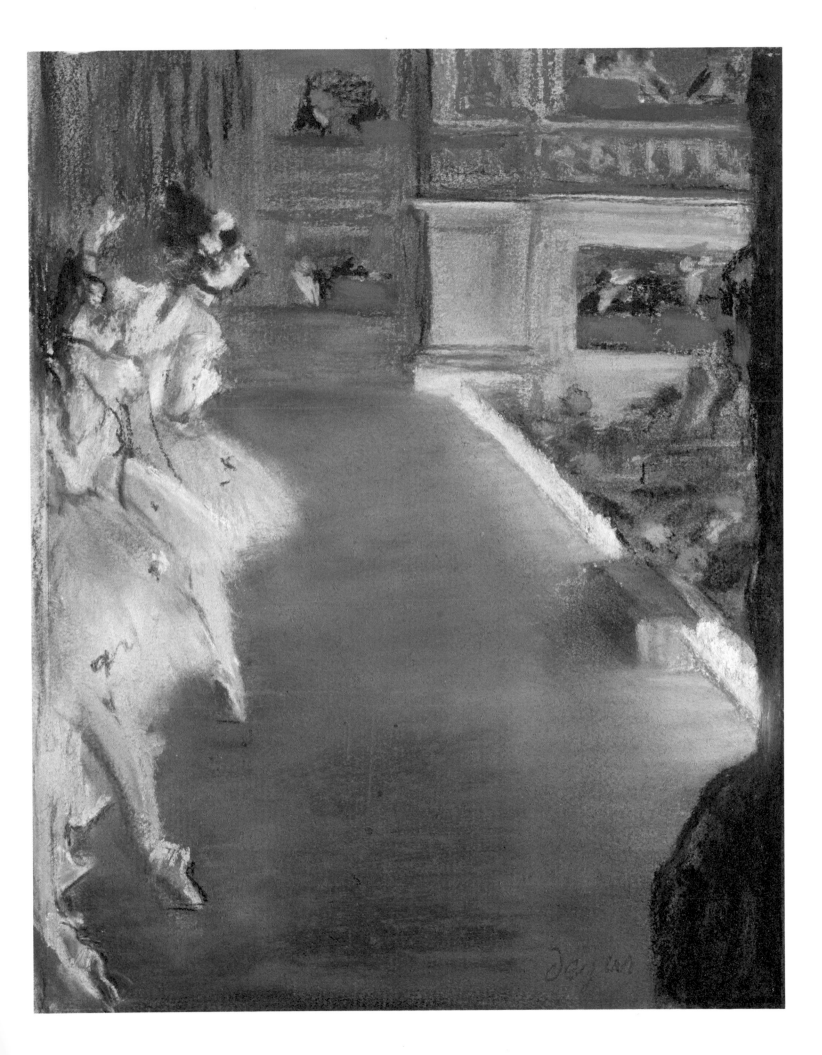

Edgar Degas

MADEMOISELLE MALO
(c. 1877)

THE SUBJECT OF THIS PORTRAIT was a dancer at the Paris Opéra with whom Degas shared a close friendship. The portrait was not given to the sitter, however, but remained in the artist's studio until his death in 1917.

Although Degas had intense friendships with women there is not the slightest suggestion that he ever fell in love with one. Undoubtedly it was the stage presence and bravura of the dancer that attracted Degas to Mademoiselle Malo, yet nowhere in this subdued and thoughtful portrait does he allude to her professional identity. He chose to paint her in a private moment. Her large, sad eyes stare vacantly; she looks as people often do when they are lost in melancholy thoughts. The generally dark tones of the painting and the relative thinness of the paint (especially in the chair and the area just below the flowers where the texture of the canvas is visible) remind us of some of Degas' earlier portraits, those more influenced by tradition. Yet the juxtaposition of the bright whites and yellows of the flowers partially mitigates the austerity of the painting and recalls the decorative Chinese and Japanese screens that were popular in France at the time.

Degas' eyesight began to fail dramatically in the late 1870s, and there is no question that he felt himself more withdrawn from life, more solitary. Perhaps in Mademoiselle Malo Degas sensed a kindred spirit.

Chester Dale Collection

31⅞ × 25⅝ in (81.1 × 65.1 cm)

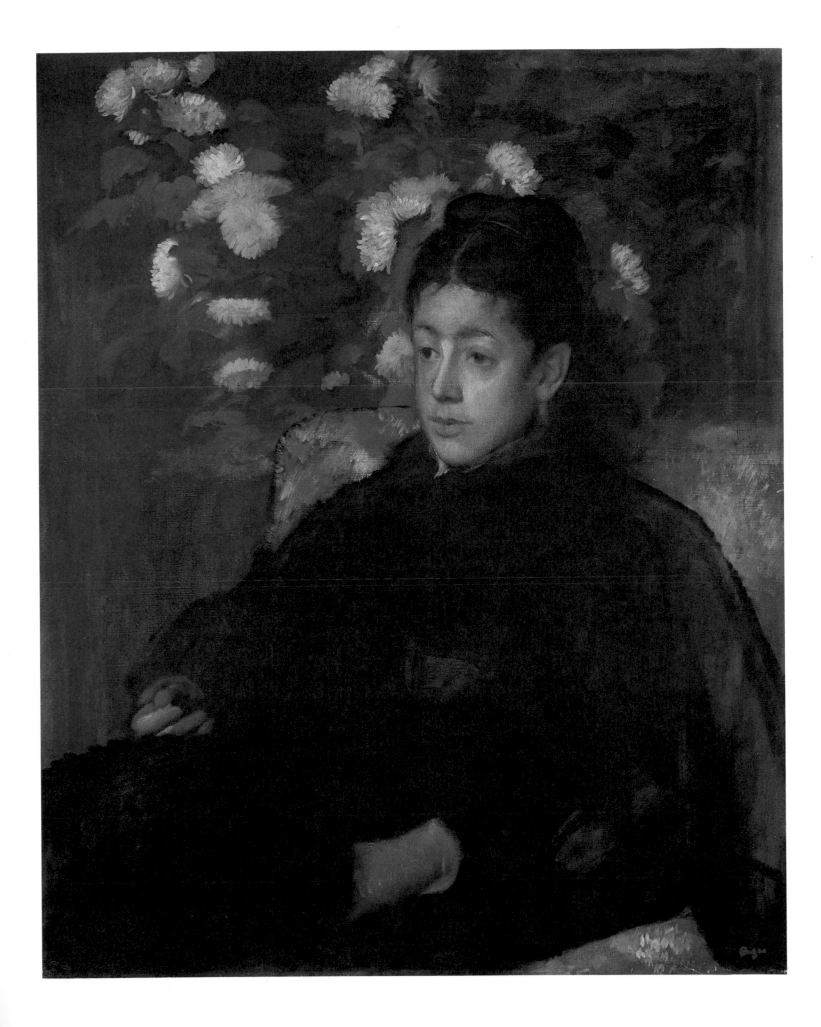

Edgar Degas

WOMAN IRONING
(1882)

DEGAS IS NOTED FOR HIS paintings of women—portraits of Parisian aristocrats, dancers and actresses, as well as working-class shopgirls and laundresses. During the 1880s he did a number of paintings that invite comparison with the literary naturalism of such contemporaries as Émile Zola. The tradition of pictures showing workers was well established, however, by the time Degas painted *Woman Ironing*. Millet, Courbet and Legros had painted mostly rural workers in the Fifties, but the most probable source of direct inspiration for this painting is Daumier, whose *Laundress* Degas saw in the retrospective organized in the former's honor in 1878.

Like Daumier, Degas creates a broad, simplified design and exploits dark contours against a light ground. While his laundress resembles Daumier's in her anonymity (her face is seen in limited profile so that we cannot speculate about her age, her state of mind), Degas is a more detached observer. He does not editorialize but rather seems to present the visual facts. His amazing selectivity and ability to distill objects makes us quickly exhaust a superficial reading of this painting in favor of a more prolonged and rewarding examination of the subtle color contrasts and the wonderful dialogue of two- and three-dimensional design that takes place between the tabletop and the hanging laundry.

Collection of Mr. and Mrs. Paul Mellon

32 × 26 in (81.3 × 66 cm)

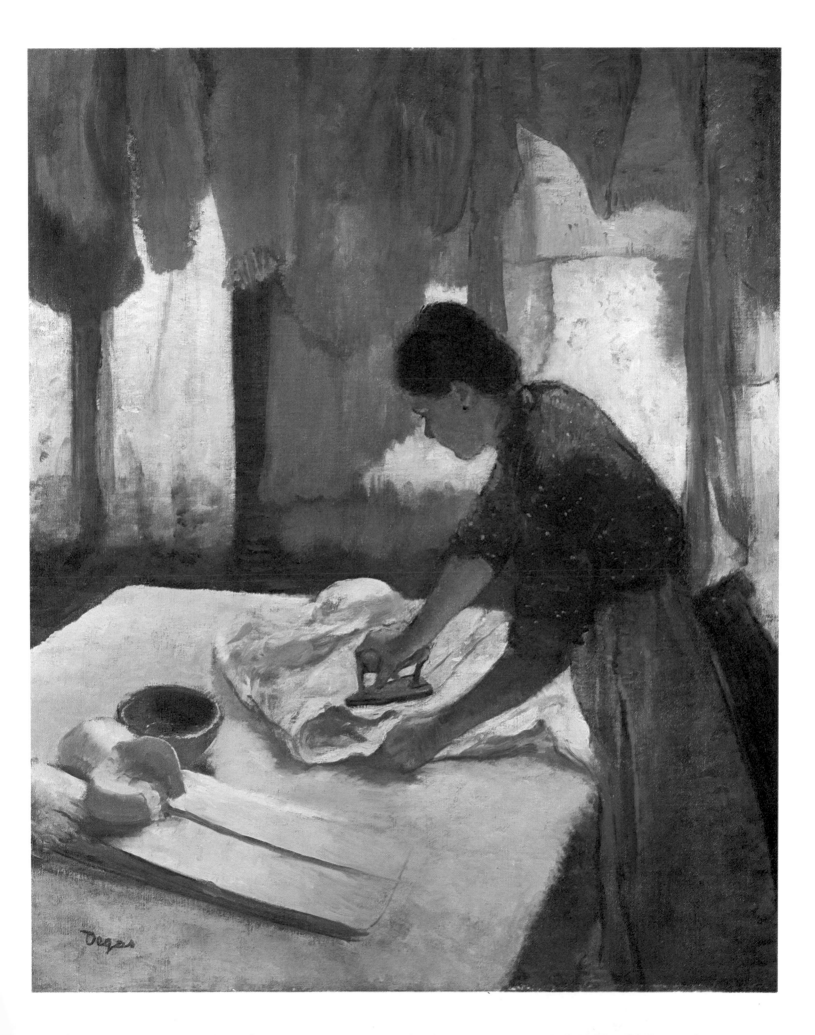

Edgar Degas

FOUR DANCERS
(c. 1899)

The Symbolist poet Paul Valéry said of Degas, "For all his devotion to dancers, he *captures* rather than cajoles them. He defines them. . . . He is like a writer striving to attain the utmost precision of form, drafting and redrafting, canceling, advancing by endless recapitulation, never admitting that his work has reached its final stage. . . ." Degas was constantly accumulating visual information about people, movement, light. He would use these memory sketches in his paintings, refining the accidental or the spontaneous into a design of such premeditated clarity that it would create the illusion of effortless spontaneity.

Dancers were foremost among his passions, and he frequently turned to the ballet for motifs. His *Notebooks*, of which thirteen are preserved in Paris, contain numerous references to them. "Of a dancer do either the arms or the legs or the back." The words seem eminently suited to *Four Dancers*, a late painting done when he had been working extensively with pastels, which he found easier to use because of his limited vision. The patterns of the bending or outstretched arms create seemingly casual yet structurally effective curvilinear patterns that contrast sharply with those of the more muted contours of the scenery and the tutus. Degas loads the figures into one corner, pressing the forms forward toward the viewer and leaving the coloristically different areas of the backdrop to function as foil for them. His use of the arbitrary vantage point, cropping of forms and his experiments with the effects of artificial lighting visible in the somewhat greenish tonalities of the dancers' skin may be considered the marks of Impressionism. However, the artist's essential grasp of decorative design reaffirms the enduring dedication to the principles of Ingres.

Chester Dale Collection

59½ × 71 in (151.1 × 180.2 cm)

Frédéric Bazille (1841–1870)

NEGRO GIRL WITH PEONIES
(1870)

THE PAINTING CAREER OF BAZILLE, the tall and elegant young friend of
Claude Monet who posed for his abortive *Dejeuner sur l'Herbe* (plate
51), was brutally ended when he was killed on the front during the
Franco-Prussian War. Having initially studied medicine, Bazille
turned to painting in the early 1860s. In the studio of the landscapist
and popular teacher Gleyre he met Monet, Renoir and Sisley, and his
close relationship with these painters later influenced him to work
directly from nature.

Before undertaking more typically Impressionist outdoor theme,
Bazille had done many still-life and figure paintings; one of his still
lifes was even accepted by the Salon jury in 1866. The *Negro Girl with
Peonies* is a work that combines a wonderfully rich study of flowers
with a picturesque though unusually sober rendering of a black serv-
ing woman. The combination of women and flowers was hardly a new
one when Bazille painted this picture, but the selection of a black
woman is somewhat unusual and may have been inspired by a detail
from Édouard Manet's *Olympia,* a controversial work done five years
earlier. Manet was a hero to Bazille, Renoir and Monet, and the three
artists were depicted as virtual disciples of the artist in a group portrait
by Fantin-Latour entitled *A Studio in the Batignolles Quarter.*

Whatever its inspiration, the painting offers impressive testimony to
Bazille's unrealized potential as an artist. The lighting is sure, the
forms are firmly defined and the color scheme (especially in the repeti-
tion of key reds and violets in the turban and peonies) is highly
effective.

Collection of Mr. and Mrs. Paul Mellon
(Loan)

23¾ × 29¾ in (60.3 × 75.6 cm)

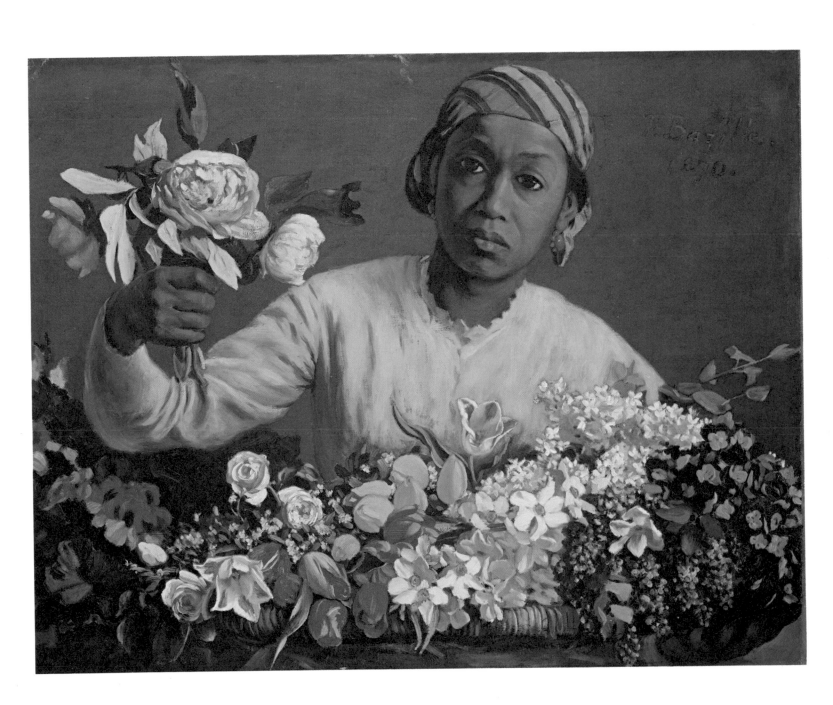

Henri Fantin-Latour (1836–1904)

STILL LIFE
(1866)

Fantin-Latour occupies an interesting position in the history of late-nineteenth-century French painting. While his work was perfectly acceptable to the official Salon, it was also respected by more innovative artists, such as his friends Manet, Bazille and Monet, but he never became a real part of the Impressionist group. An examination of this rather typical still life reveals some of the reasons why.

Unlike the still-life paintings of Monet, with their vivid colors, loose brush stroke and generous paint surface, Fantin-Latour's flowers, fruits and other familiar still-life elements are careful studies that condense the characteristic tones and textures of objects and synthesize them in premeditated compositions of clarity. His results are decidedly naturalistic; indeed the painting projects an almost photographic sharpness if compared with an Impressionist work.

He consciously selects certain details, carefully varies tones and provides just enough balance between the nominal texture of the still-life object and the texture of the paint itself to sustain the viewer's interest. While his work acknowledges a concern with verisimilitude that marked the seventeenth-century Dutch still-life painters, its immediacy and its rather studied formality speak of the new materialism of the Impressionists.

Chester Dale Collection

16 × 12⅞ in (40.7 × 32.7 cm)

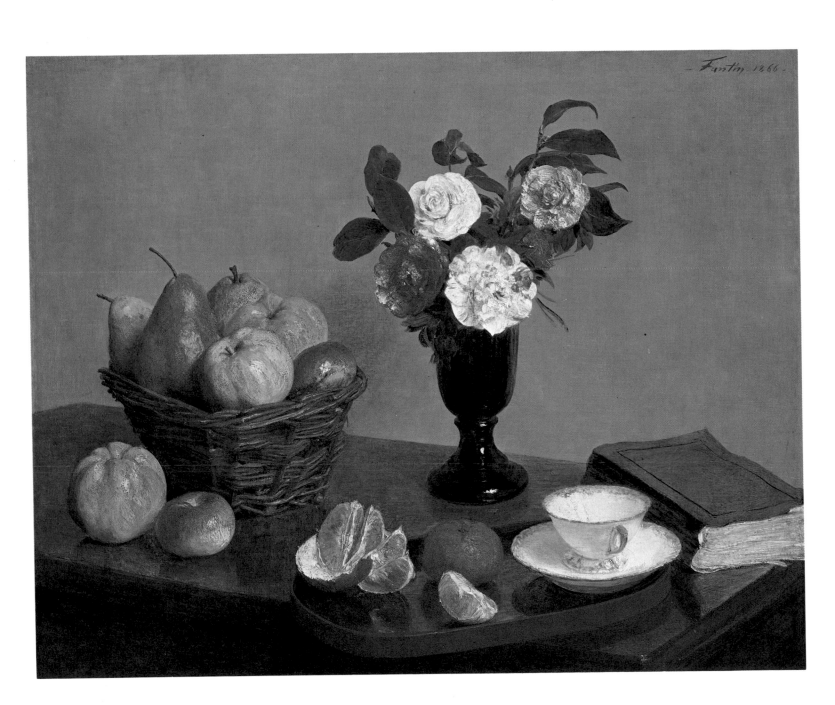

Henri Fantin-Latour

PORTRAIT OF SONIA
(1890)

THIS COOLLY ELEGANT PORTRAIT, which bears the inscription "to my dear niece, Sonia," was painted almost a quarter of a century after the preceding still life, yet the same calculated naturalism informs both works, telling us a good deal about Fantin's conservative temperament and aesthetics. The sedate color and careful brushwork remind us that the painter had never sacrificed objective form to that quest for a spontaneous, if less complete, sense of reality that marked the work of the Impressionists. The treatment of textures—fur, feathers, cloth and jewelry—is individualized, yet nowhere does a textural detail interfere with our perception of the whole. Indeed it is this very sense of proportion or careful adjustment of detail to total conception that sets Fantin apart from his Impressionist contemporaries.

Chester Dale Collection

43 × 31⅞ in (109.2 × 81 cm)

Mary Cassatt (1844–1926)

THE BOATING PARTY
(1893–94)

THE DISTANCE FROM PITTSBURGH, PENNSYLVANIA, where she was born, to Paris, where she discovered her artistic identity, must have seemed vast indeed to Mary Cassatt. She never did succeed in completely bridging the gap between her native culture and the one she adopted when she went to France in 1868 to further her study of painting. Within a few years her work attracted the attention of Degas, whose work she had admired above all her other colleagues. He was impressed by her remarkable gift for drawing and invited her to exhibit with the Impressionists, which she continued to do through 1886.

While *The Boating Party* can be seen as a typical *plein-air* Impressionist subject, it displays certain qualities that are unmistakably personal. Cassatt pays strict attention to the shapes of her figures and to the sweeping curve of the boat, partially echoed in the sail. She is insistent on the essential flatness of the canvas and has been influenced directly by Japanese prints (Cassatt had executed a suite of color etchings and aquatints inspired by Japanese wood blocks just two years prior to this painting). The inclusion of the chubby and slightly uncomfortable child introduces a sense of familial well-being, and it is this special familiarity that marks her work, giving it an accent rather different from the chic or elegance of the French.

Repeatedly Mary Cassatt painted images of women—alone in their parlors or boudoirs, with companions or female relatives and with their children. Yet she never married herself and died, nearly blind and alone, in a chateau in France.

Chester Dale Collection
35½ × 46¼ in (90.2 × 117.5 cm)

94

Mary Cassatt

GIRL ARRANGING HER HAIR
(1886)

Enormously disciplined and determined to realize her goal of becoming an artist, Mary Cassatt settled in Paris and dedicated herself to drawing, assiduously studying the work of the German Renaissance master Holbein and of the Neoclassicist Ingres. At the same time her voracious but selective eye was devouring contemporary art, and she discovered Degas, whose paintings produced an immediate and profound impact on her: "I used to go and flatten my nose against the [dealer's] window and absorb all I could of his art. . . . It changed my life; I saw art then as I wanted to see it."

The painter was already in her thirties when Degas invited her to join the Impressionists. Although the group included three other women—Berthe Morisot, Eva Gonzales and the wife of the etcher Bracquemond—the acceptance of another female and a foreigner at that was certainly a great tribute, for it could be argued that the other women all had firm social ties with influential male members of the group.

If we compare the *Girl Arranging Her Hair* (exhibited in the last Impressionist exhibition, 1886) with similar subjects by Degas or Renoir, the affinity with the former is evident. Like Degas, Cassatt chooses an extremely candid, even ungraceful pose. The awkward placement of the hands creates an area of tension between the head and the commode with its basin and carafe, making the viewer aware of the disparate fragments to the left and right of the figure and reiterating that emphasis on decorative two-dimensionality one so often finds in Degas' compositions. So impressed was Degas with this painting that he purchased it and kept it in his studio until his death.

Chester Dale Collection

29½ × 24½ in (75 × 62.3 cm)

Mary Cassatt

LITTLE GIRL IN A BLUE ARMCHAIR
(1878)

APART FROM HER ACTIVITY as a painter and as one of the most inventive printmakers of the late nineteenth century, Mary Cassatt served as "godmother" to many of America's greatest private collections—collections that have subsequently become part of this country's cultural patrimony in the great public museums. Her knowledge and taste were always at the service of the numerous relatives and friends who visited her apartment in Paris or stayed in her houses in the countryside and on the Riviera. This "transplanted American lady," as historian Adelyn Breeskin has called her, was the exact opposite of the stereotyped Paris bohemian. Proper, imbued with a work ethic that would have pleased her French Calvinist forebears, she conducted her life in much the same way she would have had she remained in Pennsylvania.

The visits of relatives and friends provided her with many congenial subjects; frequently the models for paintings were children. One of her most charming compositions was executed the year before Cassatt joined the Impressionists. Juxtaposing a dreamy little girl and a snoozing Yorkshire terrier, the painter creates a wonderful sense of complicity, as if the two had momentarily appropriated the comfortable overstuffed furniture usually reserved for adults and were luxuriating in the solitary comfort of a late afternoon.

Choosing blue as the painting's key color, Cassatt skillfully contrasts it with white and red in the slashing patterns of the chairs and sofas, or deepens it in the plaid sash and socks of the child. The only other color is brown, repeated in the hair of the child, the fur of the dog and slightly muted neutral tones of the floor. The freshness and intimacy of the conception is really all the more impressive when one thinks of the many conventional renderings of children by Cassatt's contemporaries.

Collection of Mr. and Mrs. Paul Mellon
(Loan)

35 × 51 in (88.9 × 129.5 cm)

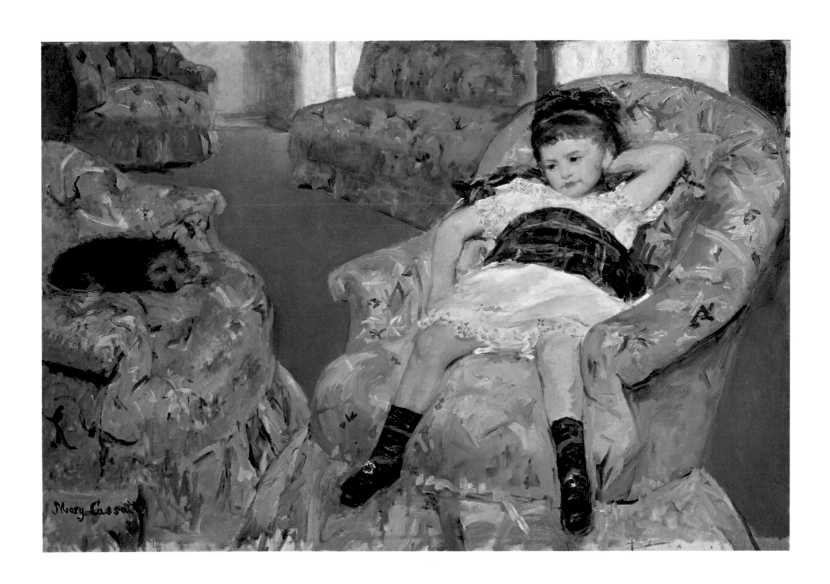

Mary Cassatt

THE LOGE
(1882)

FIGURES IN A THEATER AUDIENCE were a favorite subject for Degas, and they found their way into the work of his protegé, Mary Cassatt. Like Degas, the American painter was attracted by the lighting of the interiors, the vivid colors of the spectators and the generally unfocused excitement of the audience. In *The Loge,* the heads of the young ladies are rather crisply painted, whereas the more distant surrounding areas are treated summarily. This is the result of an assumption about the ways forms are seen—namely, that in concentrating on a main subject the adjacent or peripheral areas become somewhat blurred. Clearly, this kind of effect, the result of an optical experience, can be considered a reflection of the scientific or "documentary" concerns of Impressionism.

Like Monet and Degas, Cassatt constantly stresses the surfaces of the painting. Through her repetition of certain key colors (gold, white and green) and shapes (the fan, the curve of the loge, the light) she creates powerful abstract patterns. The heads of the young girls overlap the architectural forms, further compressing space and making it seem more fragmented.

Although we do not know the identity of these young ladies, it is tempting to speculate that they might have been well-to-do compatriots visiting Paris as part of a prescribed grand tour. Their serious, slightly vexed or withdrawn demeanors suggest the momentary discomfort of a potential social gaffe provoked by unfamiliarity of surroundings or social customs.

Chester Dale Collection

31⅜ × 25⅛ in (79.7 × 63.8 cm)

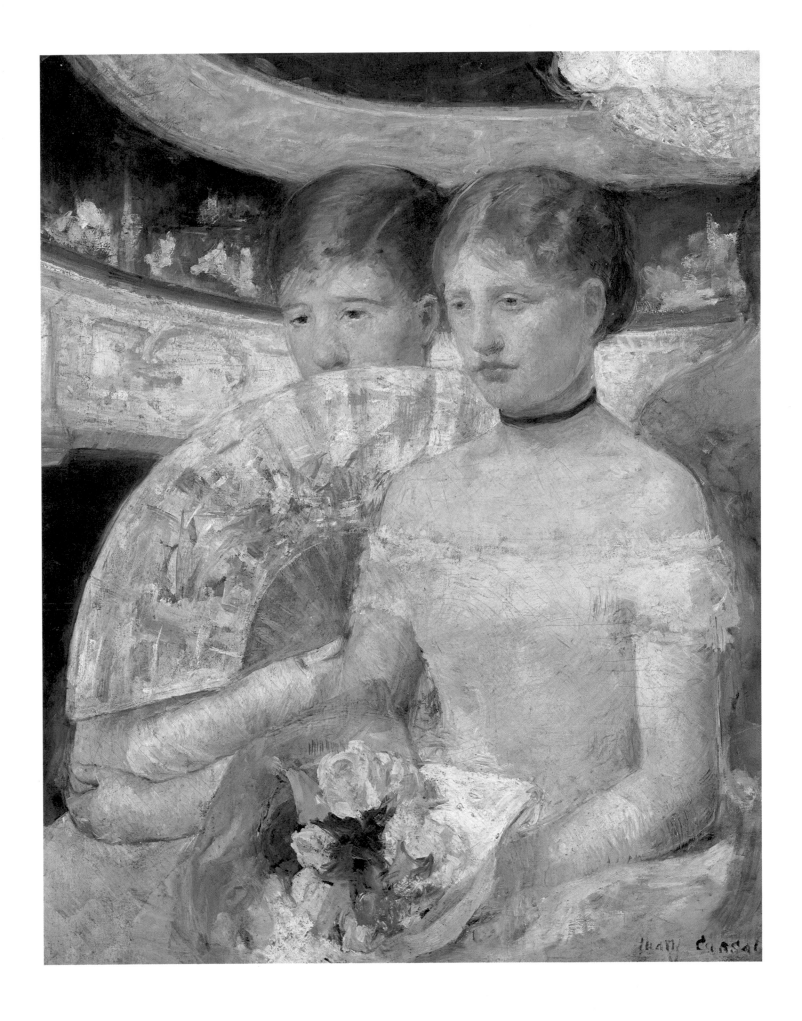

Mary Cassatt

CHILDREN PLAYING ON THE BEACH
(1884)

INTENSELY SELF-CRITICAL AND constantly striving to perfect her technical skills, Mary Cassatt would not have a one-woman show until she was forty-six years old. In the Eighties, she undertook a serious study of Japanese woodcuts in order to better understand and meet the demands of the printmaking medium in which she had begun to work. The effect of this study was to develop a new suppleness of line and a sense of economy of composition that would enrich her painting as well.

Children Playing on the Beach is typical of the selective Impressionism that Mary Cassatt practiced throughout her life. The upper section of the painting displays the broken color and resulting fugitive forms so characteristic of the style, while the rest of the composition is sharply focused and reminiscent of the simplified color and sure contours of Japanese woodcuts. Typical too of Cassatt's approach is her refusal to indulge the picturesque or sentimental qualities associated with this subject. Like the Japanese and Degas, she prefers to concentrate on its decorative potential.

Two years before she died, Mary Cassatt provided her own terse assessment of her achievements as a painter: ". . . (my) work was in studies of childhood and infancy."

Ailsa Mellon Bruce Collection

38⅜ × 29¼ in (97.4 × 74.2 cm)

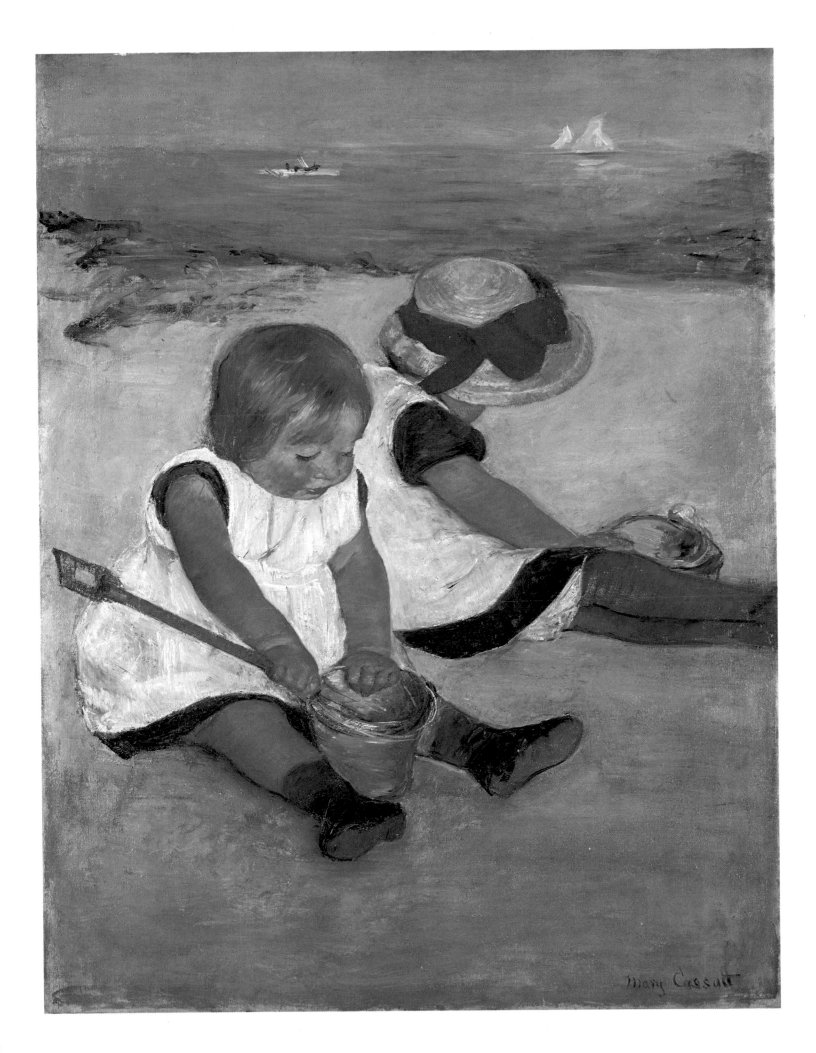

Mary Cassatt

CHILD IN A STRAW HAT
(c. 1886)

THIS DISARMING STUDY OF a sad-faced child eloquently testifies to Mary Cassatt's ability to evoke atmosphere through drastically limited means. Only four colors are used; the repetition of the dominant gray in the even, downward-moving brush strokes of the dress and background produces an image of controlled, almost resigned sadness. Only the bright yellow of the hair and of the slightly ponderous hat serve to relieve the sobriety of the work. Even the red of the little girl's cheek seems more flushed with emotion than with health or well-being.

Paintings like this had firmly established Mary Cassatt's reputation when, in 1899, she paid a visit to her family. Her arrival occasioned only this curious social notice in a Philadelphia newspaper: "Mary Cassatt, sister of Mr. Cassatt, President of the Pennsylvania Railroad, returned from Europe yesterday. She has been studying painting in France and owns the smallest Pekingese dog in the world." It is not difficult to understand why the painter considered her countrymen cultural provincials.

Despite the indifference to her work in the United States, Mary Cassatt continued to receive acclaim in Europe. In 1904 the French government made this expatriate a Chevalier of the Legion of Honor.

Collection of Mr. and Mrs. Paul Mellon
(Loan)

25½ × 19¼ in (64.8 × 48.9 cm)

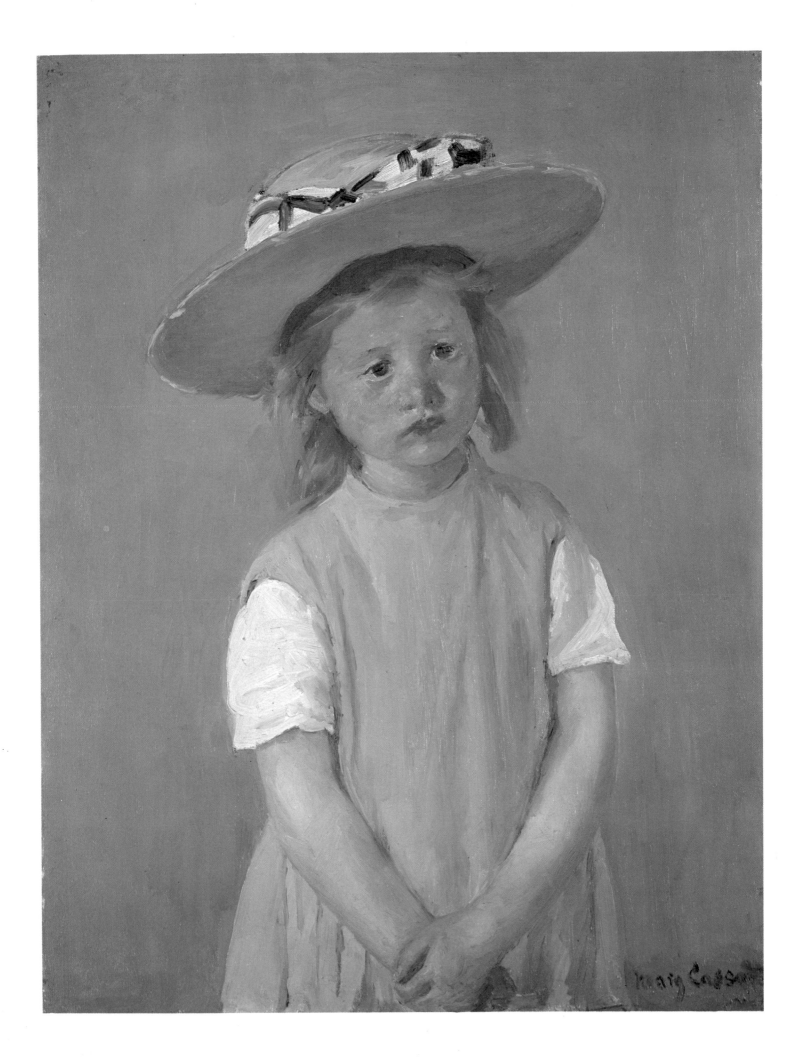

Camille Pissarro (1830–1903)

PEASANT WOMAN
(1880)

Pissarro was the oldest Impressionist and seems to have been esteemed and loved by virtually all the members of the group as a generous friend and a patient and wise counselor. Born in the Virgin Islands, he decided to study painting in Paris and arrived there in 1855, the year of the great World's Fair with its exhibitions in honor of Ingres and Delacroix and Courbet's "Pavilion of Realism." He studied the work of the latter (whose daring compositions of peasants and rural workers shocked both public and critics) and of Corot.

Pissarro's *Peasant Woman* was painted after six years of exhibiting with the Impressionists (he was the only member of the group to participate in all of their shows), and it reveals that while Pissarro used a fresh palette and applied paint generously, his touch was quite controlled and he produced solid, constructed forms. A comparison of Renoir's figures in landscape settings with those of Pissarro's reveals that the latter's emerge more clearly from the leafy background despite the uniformity of the brush strokes. Moreover, there is a sobriety in Pissarro's figure studies and in many of his landscapes that departs from the scintillating gaiety of Monet or Renoir. One feels that this good and gentle man had a special sympathy for his subject, that he respected the labor of this farm woman and that he sought to convey by means of a painted equivalent something of the solidity and stability of her social identity.

Chester Dale Collection

28¾ × 23⅝ in (73.1 × 60 cm)

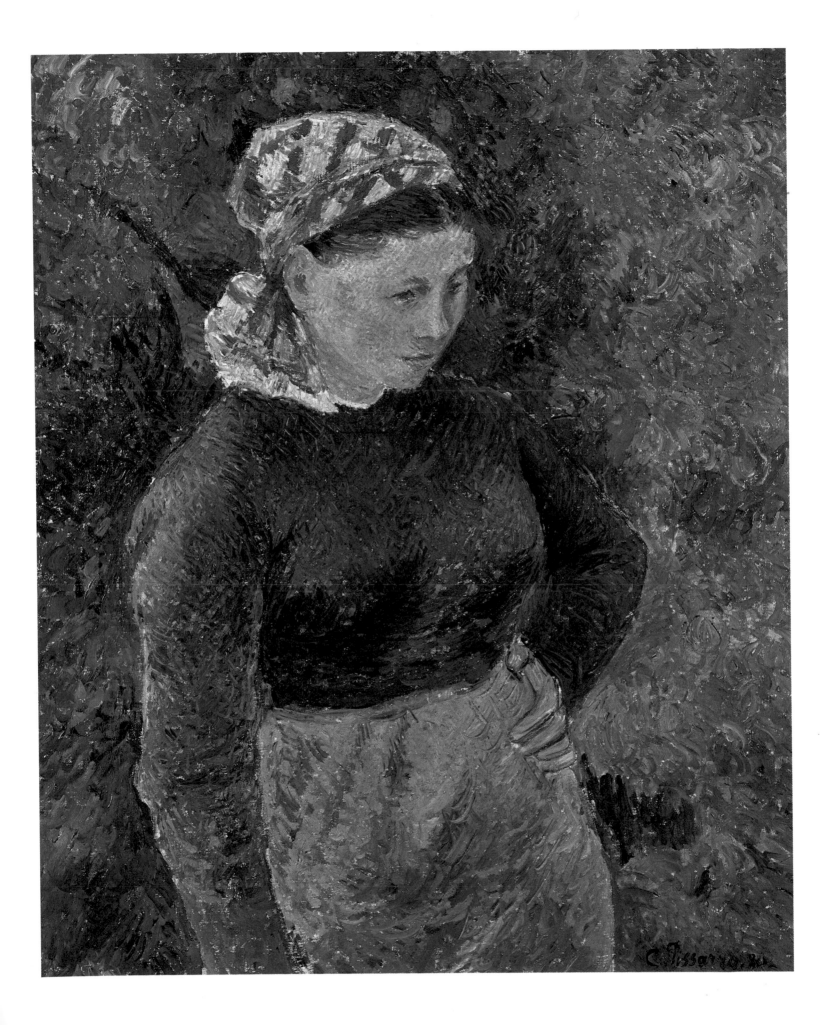

Camille Pissarro

ORCHARD IN BLOOM, LOUVECIENNES
(1872)

OF ALL THE IMPRESSIONISTS, Pissarro was unique in his avoidance of sea and riverscapes. He was drawn to the beauty of the land, to its infinite variations and to the plain labors of the people who toiled its fields. Unlike Monet, who exhorted young painters to forget what they were looking at in their pursuit of an essential light or color sensation, Pissarro never lost contact with a *place*.

By 1872 Pissarro was mixing color directly on his canvases. He also was attempting to find a middle ground between the "instantaneity" sought after by Monet and the set and rigid landscapes of the academicians. The bright, clear sky and simple, sturdy forms in this painting emphasize the commonplace that is characteristic of Pissarro's approach, yet the work very definitely conveys an overwhelming sense of moment. There is an echo of the much admired Corot in Pissarro's compositional device of utilizing a pale blue—in the trousers of the man, the skirt of the bending woman—to contrast with the earth tones and key the eye to the marvelous color of the sky.

In 1872 Pissarro worked closely with Cézanne at Pointoise, where he introduced Cézanne to *plein-air* painting and persuaded him to lighten his colors. Pissarro's influence on younger painters such as Cézanne and later Gauguin seems almost as important as the painted *oeuvre* he left behind. The American Impressionist Mary Cassatt maintained that "He was so much of a born teacher that he could have taught the very stones to draw correctly," and Cézanne generously acknowledges his importance by declaring, "Perhaps we all of us derive from Pissarro."

Ailsa Mellon Bruce Collection

17¾ × 21⅝ in (45 × 55 cm)

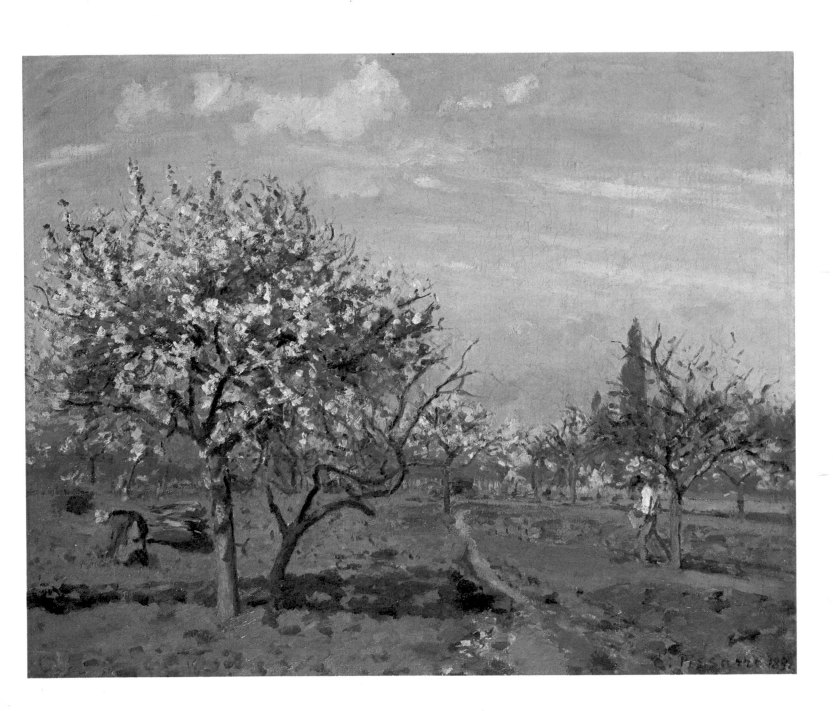

Camille Pissarro

BOULEVARD DES ITALIENS, MORNING, SUNLIGHT

(1897)

JUST ABOUT FIVE YEARS BEFORE his death, Pissarro had his first taste of financial success when the dealer Durand-Ruel organized a show of the many Paris scenes he had executed in the 1890s.

In the mid-Eighties Pissarro had attempted to lend more substance to his paintings by utilizing the divisionist technique developed by Georges Seurat, but he abandoned this more analytical and scientific approach in favor of a return to a qualified Impressionism in his city views. Painted from a room overlooking the busy thoroughfare, *Boulevard des Italiens, Morning, Sunlight* typifies the vitality of these paintings with their sense of bustling, casual movement and a clear balance of fleeting images with a firm, reassuring structural presence.

An English critic had chided Pissarro for the manner in which he had painted a view of the city of Rouen some years before, but his criticism is relevant to this work insofar as it expresses the opinion that certain elements of the composition appear ". . . just as might happen in a photograph." We know that many of the Impressionists were affected by the development of photography. The stereoscopic photographs that were popular in the 1860s project comparable images—blurred, seemingly casual, arbitrarily truncated and invariably spatially oblique. Like Monet and Degas, Pissarro was receptive to the aesthetic properties of these supremely modern and detached "documents." For Pissarro, who had always seemed so much a man of the country, the city exercised a special fascination. "I am delighted to paint these Paris streets that are generally considered ugly, though they are so silvery, sparkling and full of life."

Chester Dale Collection

28⅞ × 36¼ in (73.2 × 92.1 cm)

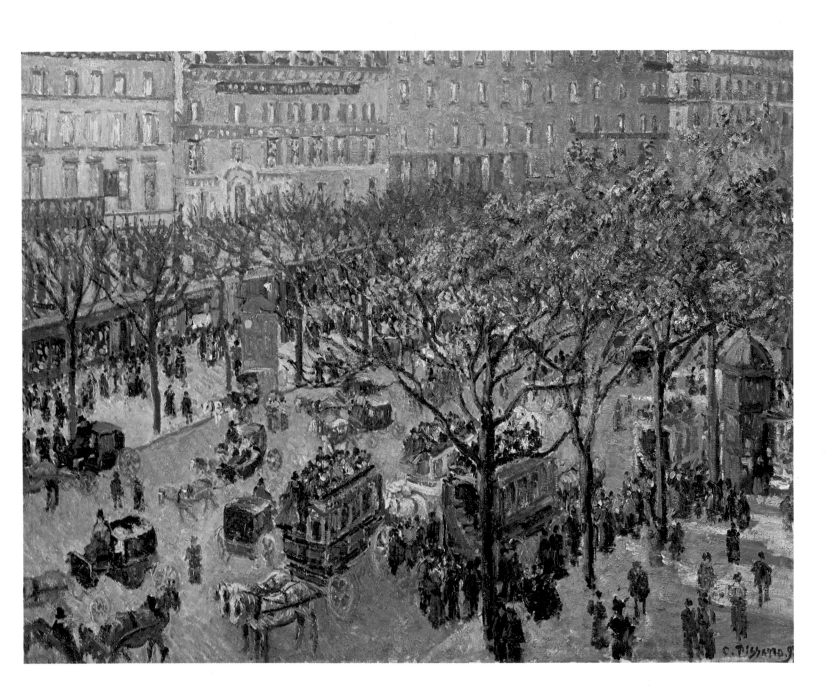

Alfred Sisley (1839–1899)

MEADOW
(1875)

Born in Paris of English parents, Sisley spent four years in London preparing for a business career. In 1862, with his father's consent, he returned to Paris and entered the studio of Charles Gleyre, one of the most liberal teachers at the École des Beaux-Arts, where he met Claude Monet, Renoir and Frédéric Bazille. When Gleyre closed his studio just two years later, Sisley began working directly from nature in the countryside near the forest of Fontainebleau, where Corot, Daubigny and Rousseau had painted two decades before.

From the early 1870s Sisley developed a style of painting that is comparable to Monet's and Renoir's early Impressionism. Like Monet, he was particularly interested in river themes and in the capacity of the water surface to reflect light. However, his brush stroke is more firm, more insistent in its definition of forms, and this, plus a tendency to define space in more conventional terms, distinguishes him from the searchers for spontaneous impressions.

It is tempting to read into a painting like *Meadow* certain English characteristics. We know that Sisley admired the landscapes of John Constable—particularly his wonderfully alive cloud studies—and we may find a homely lyricism in this work that strikes us as just a bit English. Yet Sisley's real hero was not Constable but Corot, whose serene and gentle landscapes provided an ongoing inspiration for him in the face of critical indifference to his works.

Sisley was an interesting exception to the other Impressionists in that he neglected the human figure. While there may be, as in this painting, an occasional tiny form or two, they are compositional devices. The blue of the standing and bending figures, for example, moves the viewer's eye from the broken yellows and greens of the sun-drenched meadow toward the sky.

Ailsa Mellon Bruce Collection
21⅝ × 28¾ in (54.9 × 73 cm)

112

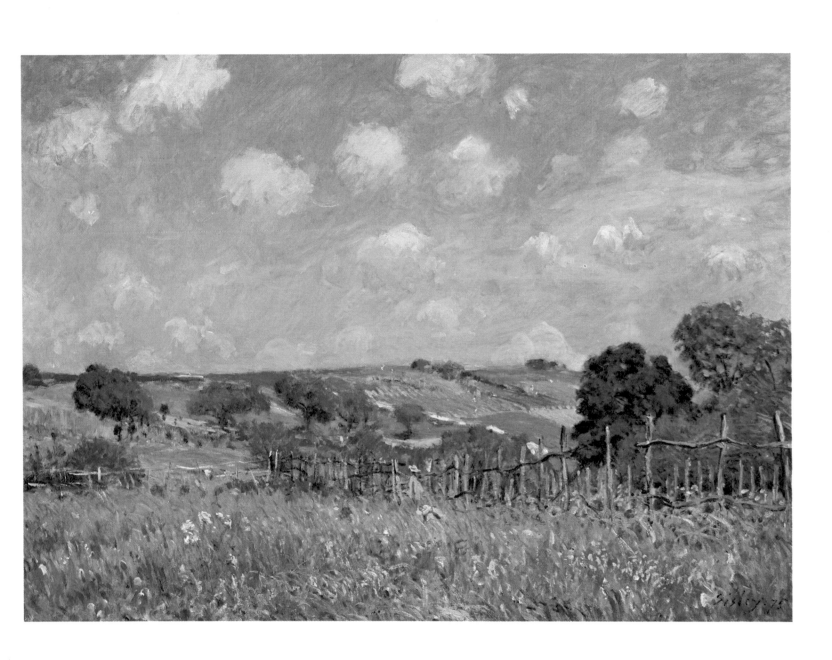

Georges Seurat (1859–1891)

SEASCAPE AT PORT-EN-BESSIN, NORMANDY
(1888)

By 1886, THE YEAR IN WHICH the last Impressionist exhibition was held, a substantial number of painters had become disenchanted with the goals and methods of Impressionism. In fact, the last show was dominated by the work of younger artists such as Georges Seurat, whose entry, *Sunday Afternoon on the Island of La Grande Jatte,* proclaimed the painstaking discipline of a technique that would be labeled Neo-impressionism in an attempt to explain its relation to the earlier style. For Seurat, Impressionism had proven inadequate because it had concentrated on the recording of ephemeral visual experience and therefore had failed to impart that sense of enduring form that is the result of careful pictorial construction.

Seurat called his new technique divisionism because he divided or separated colors into their component parts, creating canvases of such structural stability that the forms seem almost geometric. Like the Impressionists, Seurat drew his inspiration from contemporary life, and a considerable number of his paintings are seascapes.

Seurat carefully chose his locations, and he seems to have sought a setting that would allow him to exploit a particular type of rectilinear organization that he favored. The firm sense of contour visible in the cliff, the horizon line of the sea and the regularities of the color reveal the painter's intention of imposing order.

With his scientific mind, Seurat had carefully studied the color theories of the past, but he was highly informed about contemporary physics and optics as well. He believed that the aesthetic goal of art was harmony, and he avoided any suggestion of conflict or struggle in his work. This striving for harmony led him to utilize the ancient Greek concept of the "Golden Section," meaning that the larger and smaller parts of a work should stand in relation to one another as the larger stood in relation to the canvas in order to fix the proportion of the whole.

Seurat's concept of harmony led him to consider the importance of the frame as well. Unlike the Impressionists, he did not wish to call attention to the edge of the canvas, so he developed a way of painting a mediating band or frame composed of tones that oppose (in this case they are darker) those in the seascape itself. This frame is clearly visible in *Seascape at Port-en-Bessin.*

Gift of the W. Averell Harriman Foundation in memory of Marie N. Harriman

25⅝ × 31⅞ in (65.1 × 80.9 cm)

114

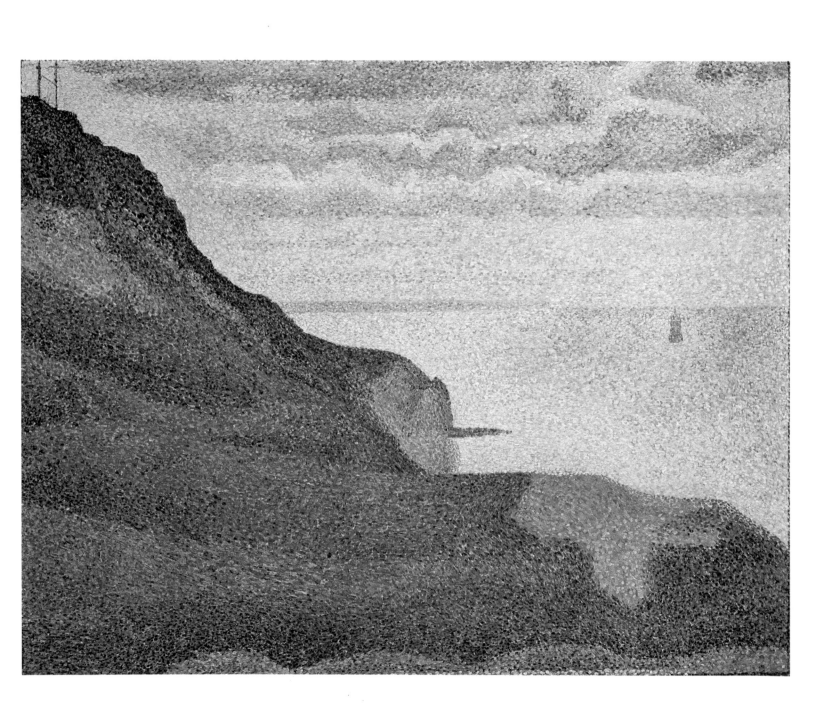

Georges Seurat

THE LIGHTHOUSE AT HONFLEUR
(1886)

Sᴇᴜʀᴀᴛ ᴡᴀs ᴏɴʟʏ ᴛʜɪʀᴛʏ-ᴛᴡᴏ years old when he died, yet in his brief career as an artist he enjoyed the respect of countless artist contemporaries such as Camille Pissarro, who was among the first to recognize the significance of Seurat's systematized Neoimpressionism and who generously propagandized on its behalf to fellow artists and dealers.

While at the École des Beaux-Arts Seurat had studied with a former pupil of Ingres, and he maintained the respect for the formal value of line associated with that master even while studying Delacroix's color theories. When Seurat realized that neither Delacroix nor the Impressionists had attempted to formulate a method of controlling color, he set about developing his system of painting in small, evenly shaped dots of approximately equal size. In an article written by Félix Fénéon, one of the earliest champions of Neoimpressionism, the advantages of the technique were cited, and the critic rightly describes the aims that are reflected in that exquisite, geometric clarity and timeless structure that are the stylistic characteristics of *The Lighthouse at Honfleur:* "To synthesize the landscape in a definitive aspect which perpetuates the sensation [it produces]—this is what the Neo-impressionists try to do. (Further their method of working is not suited to hastiness and requires painting in the studio.)"

In the last analysis, the uniform execution and serene forms in Seurat's paintings suggest that he had a much greater affinity with such masters of mathematically plotted compositions as the early Renaissance painter Piero della Francesca than he did with contemporaries like Monet.

Collection of Mr. and Mrs. Paul Mellon
(Loan)

26¼ × 32⅜ in (66.7 × 82.2 cm)

116

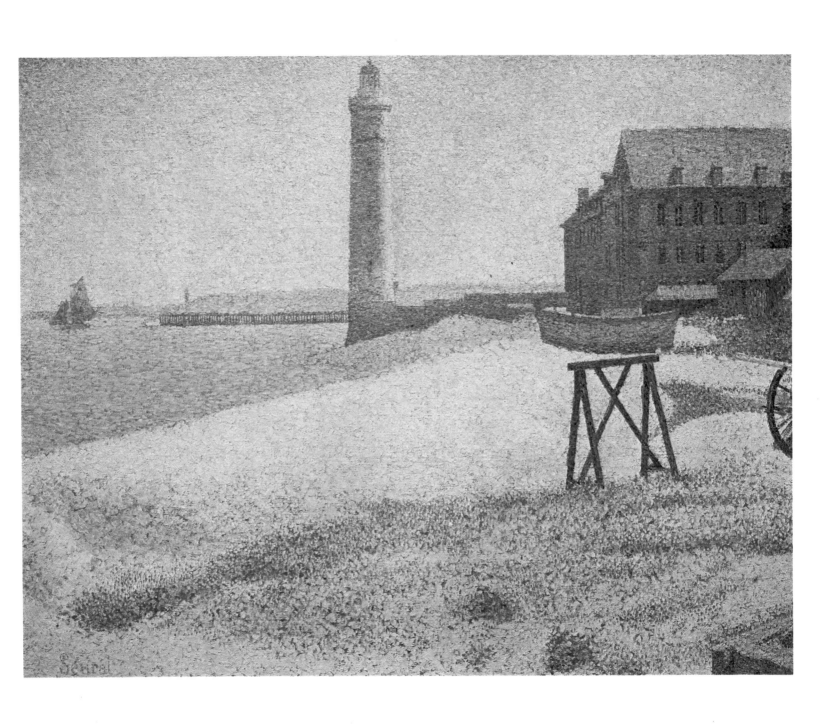

Vincent van Gogh (1853–1890)

FLOWER BEDS IN HOLLAND
(1883)

VINCENT VAN GOGH's minister father had three brothers who were art dealers, and, as the older of two sons, the future painter had been named after his most successful uncle, who was in charge of the Hague branch of a famous Paris gallery. At the age of sixteen Vincent was apprenticed in this firm and spent more than six years working in its Dutch, Belgian and English branches before his career as a would-be art dealer was abruptly terminated when he quarreled violently with his employers.

Restlessly searching to fulfill deep, spiritual needs, Vincent seriously considered following his father's calling, but his desire to give expression to his emotions ultimately drew him to painting. The enormous conflict that accompanied his decision to become a painter was to intensify even as his professional identity developed.

After studying privately with a Dutch painter, Vincent attended the academy in Brussels but left because he felt that the traditional teaching offered did not meet his creative and spiritual needs. For nearly three years Van Gogh taught himself to draw and to paint. Returning to his father's parsonage at Neunen in 1883, he painted his daily experience, his subjects being the town and its surrounding mills, fields and simple farm dwellings. Most of this early work was done in watercolor, and the relatively small number of oils were usually gray in tone, suggestive of the somewhat melancholy atmosphere of his native land. *Flower Beds in Holland* departs from these works in that the understated brown huts and barren trees are contrasted with the regular geometric shapes and bright colors of the flower beds. Still, the controlled exuberance of palette and brush gives no hint of the emotional tenor of the artist's later landscapes.

Collection of Mr. and Mrs. Paul Mellon
(Loan)

19⅛ × 26 in (48.6 × 66 cm)

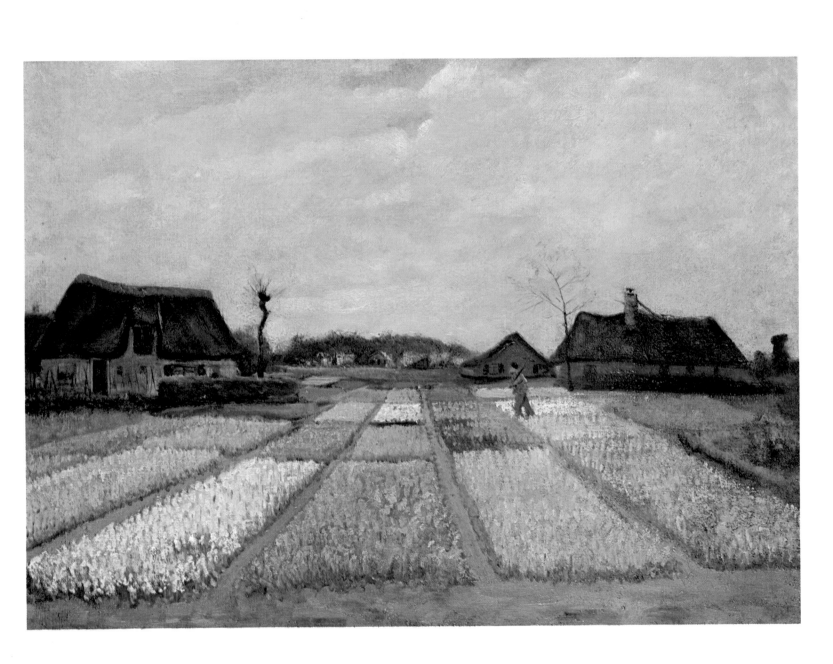

Vincent van Gogh

LA MOUSMÉ
(1888)

WHILE SEURAT'S REACTION AGAINST Impressionism was based on his dissatisfaction with its lack of logic or scientific formula, other artists felt restricted by the emphasis on visual sensation and believed that the stressing of the purely material had led to the neglect of essential human values. They were anxious that painting once more concern itself with feeling and emotions and not merely with appearances. Although linked to Impressionism in his insistence on painting the subject directly—whether it was a portrait or a view of wheatfields in the intense heat of the summer sun—the paintings of the tragic Dutch artist Vincent van Gogh represent a sharp break with the objective tenets of Impressionism.

Encouraged and supported by his art-dealer brother Theo, Van Gogh dedicated himself to painting after a difficult period in his life in which, although he failed to become a minister, he did work among the desperately poor miners of Belgium. Van Gogh was thirty-three when he arrived in Paris (his arrival coincided with the last Impressionist exhibition), and the artist's remarkable development within a relatively short period of time was the result of an enormous and passionate effort to learn that was certainly facilitated by the contacts he made through his brother. Still, nothing could quite explain the peculiar combination of idealism and mental instability that prompted him to leave the city to find a more congenial working milieu in the Provençal city of Arles.

Drawn by the promise of a simpler and quieter existence, Van Gogh at first responded positively to the city and its inhabitants. He fairly exploded with creative energy, and among the many works he produced in 1888 were a number of portraits such as this study, of which he wrote, "It took me a whole week. I have not been able to do anything else, not having been well . . . but I had to reserve my mental energy to do the *mousmé* well. A *mousmé* is a Japanese girl—Provençal in this case—12 to 14 years old." That Van Gogh should have chosen to see the young French girl as a Japanese is not surprising, given his admiration for Japanese prints, which he had collected and which he sensitively copied. The painter admired above all the clarity of these prints and the ability of the Oriental artist to put ". . . flat tones side by side, with characteristic lines marking off the movements and the forms."

Chester Dale Collection

28⅞ × 23¾ in (73.3 × 60.3 cm)

120

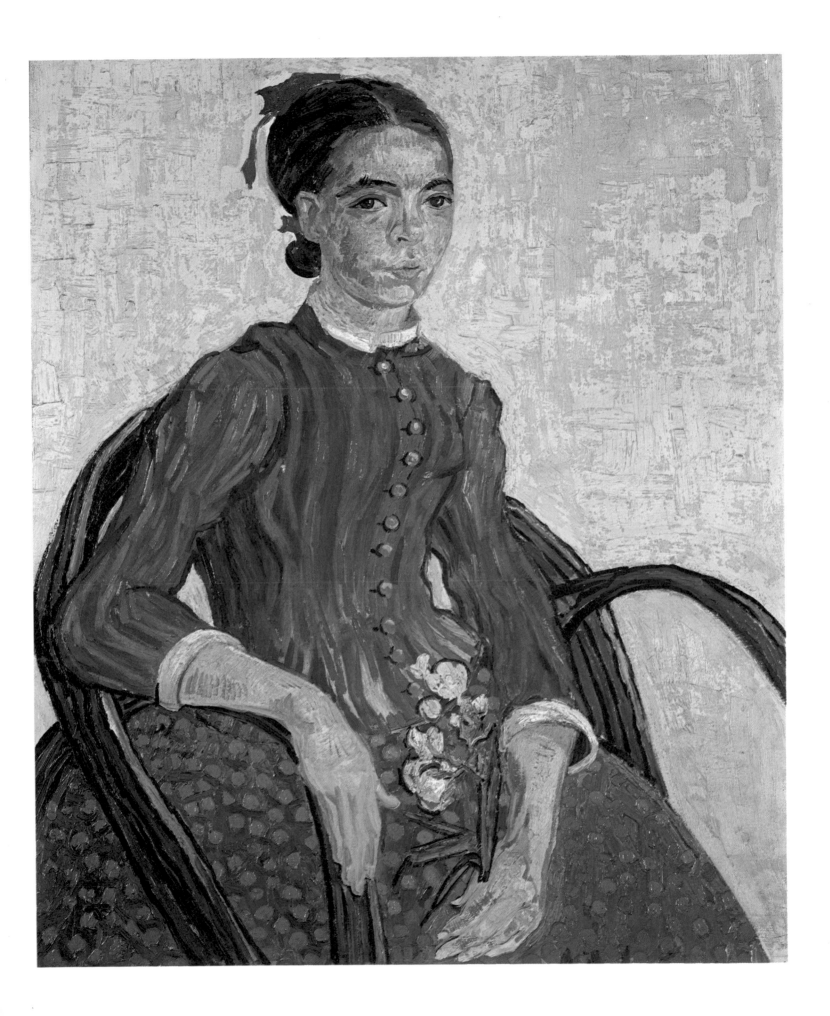

Vincent van Gogh

FARMHOUSE IN PROVENCE, ARLES
(1888)

WHILE VAN GOGH'S ARTISTIC development during his two-year stay in Paris was greatly affected by his exposure to Impressionism, his move to Arles in February 1888 signaled the beginning of a period in which he emphatically rejected that method of painting. He wrote, "Instead of trying to imitate exactly what is before my eyes, I am using color in a much more arbitrary way in order to express myself more strongly." Attempting to capture and recreate the rhythmic vitality of nature, he evolved a style of which the key components are strong, symbolic color and an energized calligraphy. Van Gogh identified his emotions with colors, assigning them a symbolic meaning; for example, he considered yellow the color of love or friendship. Hence, the intense yellows and oranges of *Farmhouse in Provence, Arles* are not simply the logical vehicles for conveying the effect of a sun-drenched field on a summer's afternoon; they also reflect the exhilaration and almost unbearable joy the painter experienced in his first months in Arles.

Van Gogh had gone to Provence in search of a "different light," and in the volatile climate of the south he found a thousand exciting motifs. So feverish was his activity in those months that he described himself as a "painting locomotive" in a letter to his brother.

Ailsa Mellon Bruce Collection

18⅛ × 24 in (46.1 × 60.9 cm)

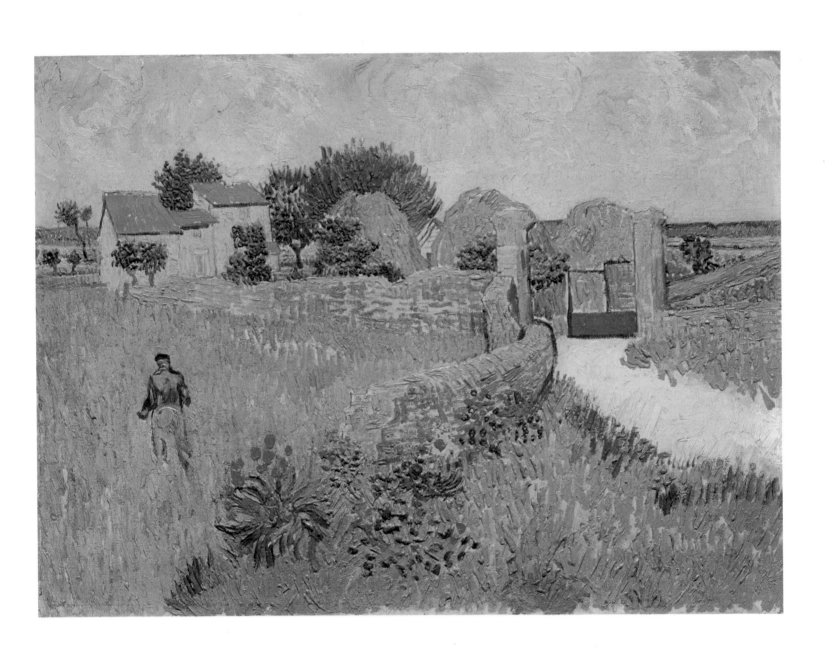

Vincent van Gogh

THE OLIVE ORCHARD
(1889)

Vᴀɴ Gᴏɢʜ ᴅᴇᴄɪᴅᴇᴅ ᴛᴏ sᴇᴛᴛʟᴇ in Arles because he had grown tired of the long, gray Parisian winter and of the petty quarrels and competitiveness of his artist aquaintances. He had long dreamed of a community of artists who would live and work together sharing ideas. He hoped to realize this artistic utopia in the warm and reassuring sun of Provence, and his initial months in Arles were indeed happy and productive ones. In September 1888 he succeeded in persuading Paul Gauguin, whom he had met in Paris and whose work he admired, to visit him. This invitation resulted in disaster. The presence of Gauguin, a strong and willful personality and an artist with a sophisticated aesthetic, was destructive to Van Gogh. Moreover, Gauguin worked from memory, whereas Van Gogh required direct contact with nature. An unbearable tension developed as Van Gogh sought to meet Gauguin's criticisms of his method of working. Van Gogh broke down under the strain and cut off an ear. From then on his life was a nightmare of ongoing mental deterioration, including hospitalization in an asylum and finally a period of slow recuperation and relative calm in a sanatorium near Paris just previous to his suicide in 1890.

The Olive Orchard was probably painted during the period when Van Gogh was a patient in the asylum at St. Rémy, near Arles. When he was not suffering from hallucinations or other extreme symptoms of his illness, the artist was given comparative freedom and he executed about 150 canvases. In a letter to a friend written while Van Gogh was still at St. Rémy he speaks of the importance of nature as his true guide and inspiration: ". . . I am working at present among the olive trees, seeking after the various effects of a gray sky against a yellow soil, with a green-black note in the foliage. . . ." The low-keyed tones of the landscape evoked through a generous paint surface project a quiet sadness that seems a marked contrast to the writhing and agitated lines of the trees and branches.

Unlike the Impressionists, who generally viewed nature with the detached eye of the reporter, Van Gogh saw it with the passionate and prejudiced gaze of a lover and sought to find formal equivalents for this ecstasy or dejection. ". . . I devour nature with my eyes. I exaggerate and sometimes alter the subject, but I do not invent. . . ."

Chester Dale Collection

28¾ × 36¼ in (73 × 92 cm)

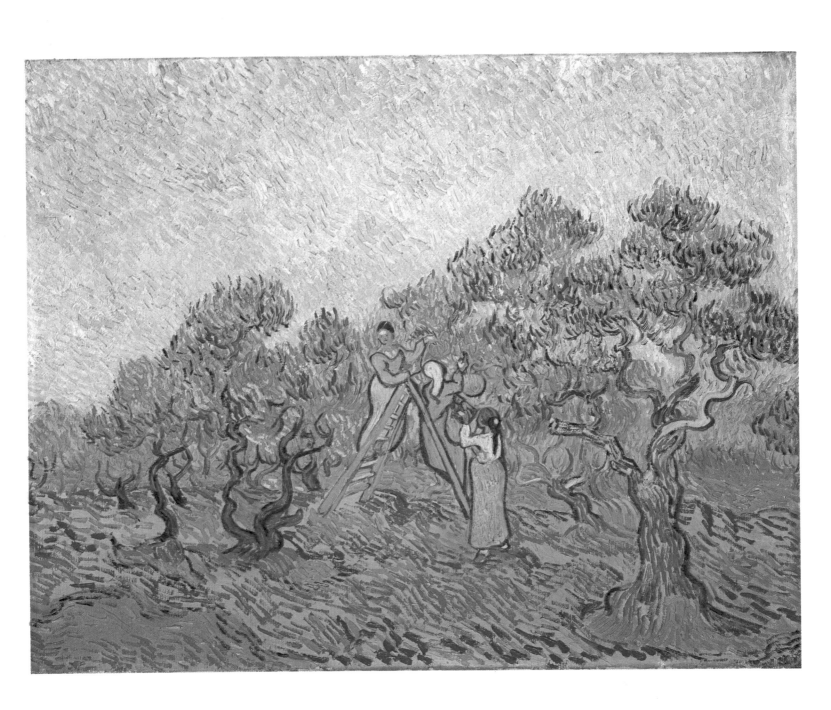

Paul Gauguin (1848–1903)

SELF-PORTRAIT
(1889)

PAUL GAUGUIN WAS A MEMBER of a Paris brokerage firm and an amateur painter who met Camille Pissarro and, with his encouragement, exhibited with the Impressionists in 1880. Three years later, convinced of his skills as a painter, Gauguin left his comfortable position to embark on the perilous career of an artist. His decision meant the end of his life as respectable bourgeois, and it resulted in a bitter separation from his wife and five children. To achieve his artistic goals, Gauguin left France in search of a more simple existence in the distant South Pacific. He became the very prototype of the bohemian artist—selfish hedonist and selfless martyr—as we see from this symbolic *Self-Portrait*, painted shortly after his tragic stay with Van Gogh in Arles.

The strong complementary reds and yellows suggest passion and intensity of feeling on the one hand and a kind of sanctity (reinforced by the introduction of the halo) and purity on the other. The apple and the snake are conventional allusions to temptation and sin—and remind us that Adam and Eve's downfall came as a result of arrogant curiosity. The rueful expression of the artist suggests the dilemma of literally being between good and evil, worldliness and innocence.

The hallmark of this work is simplicity of form and a pronounced inclination to decorative abstraction evident in the terse but rhythmical lines and flat vibrant color. Gauguin had been critical of Impressionism as ignoring the role of the imagination in its stress on nature. While his work, like that of Van Gogh, stresses emotion, it is more cunning, more planned. For Gauguin, ". . . the great artist is synonymous with the greatest intelligence; he is the vehicle of the most delicate, the most invisible emotions of the brain."

Chester Dale Collection
31¼ × 20¼ in (79.2 × 51.3 cm)

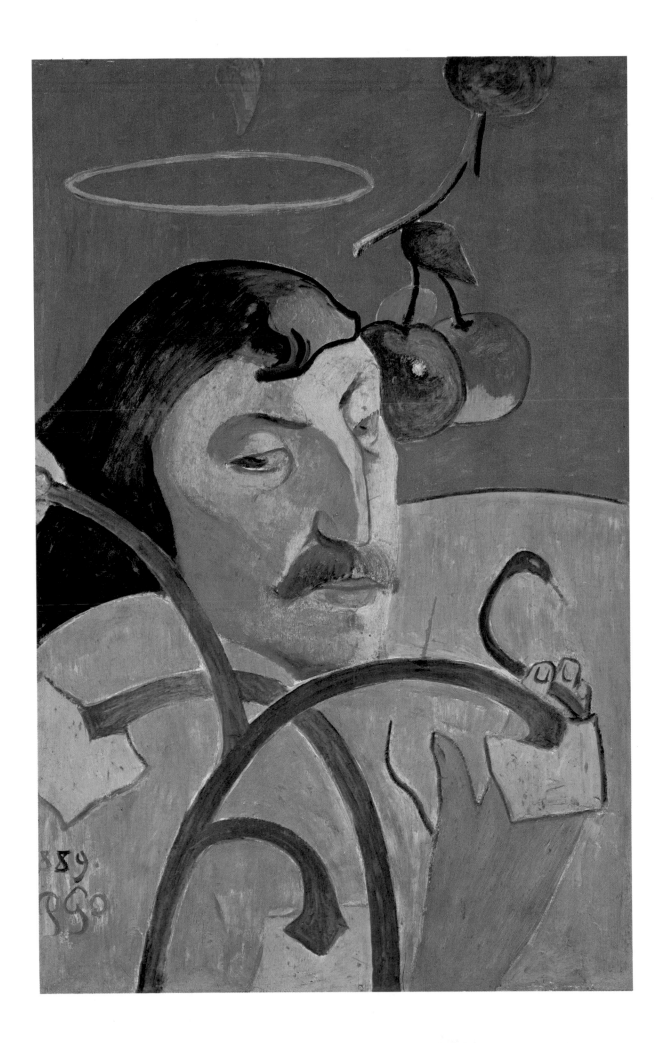

Paul Gauguin

BRETON GIRLS DANCING, PONT-AVEN
(1888)

PERHAPS BECAUSE HE HAS seemed so much the embodiment of the popular notion of a bohemian fleeing from middle-class convention, Paul Gauguin's Tahitian paintings have garnered more attention than his earlier work. Yet anyone who studies this image of dancing farm girls executed before the artist's fateful trip to Arles cannot fail to notice the link with his later paintings. The simplified colors, strong contours and the "naïve" subject represent one of Gauguin's earliest efforts to forge a new style.

Gauguin had first settled in the village of Pont Aven in Brittany two years earlier, and there, inspired by indigenous folk art and by crude popular woodcuts, began to explore the decorative and symbolic values of line and color that would be orchestrated in the South Pacific paintings. Rejecting both the illusionism of post-Renaissance art and the naturalism of the Impressionists, Gauguin sought the evocation of a mood through color and line relationships. He cautioned his fellow artists: "Do not copy nature too much. Art is an abstraction: you should derive it from nature which you contemplate as if in a dream." In Paris and in Brittany Gauguin enjoyed friendships with a number of great writers, including the Symbolist poets Paul Verlaine and Stéphane Mallarmé, and he shared with them not only a love of the remote and mysterious but a firm belief in the sensuous and essentially irrational nature of art. Moreover, he saw an analogy between art and music in the former's ability to "act on the soul through the intermediary of the senses, the harmonious tones corresponding to the harmonies of sounds. . . . "

In this painting, the artist does not describe the life of rural folk as the sixteenth-century Flemish master Pieter Brueghel did, nor does he seek to utilize them as symbols of inherent dignity and piety as the landscapist Millet had done. Rather, he uses strong rhythmic lines and decorative pale colors to create a design that is the formal equivalent of timeless innocence associated with the subject.

Collection of Mr. and Mrs. Paul Mellon
(Loan)

28½ × 36¼ in (72.4 × 92.1 cm)

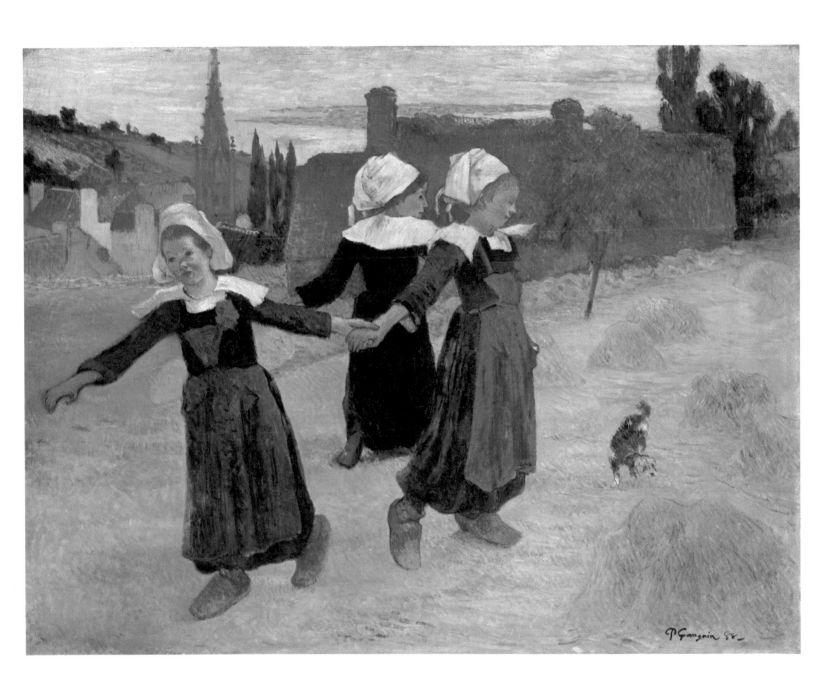

Paul Gauguin

FATATA TE MITI (By the Sea)
(1892)

FOR SEVERAL YEARS GAUGUIN had longed to flee the ugliness and banality of urban life. His attraction for exotic places had led him to Martinique in 1887, but he had been forced by sickness to return to Paris. One day he saw a brochure of Tahiti and was convinced that he would find artistic fulfillment in this remote paradise. The direct impact of this strange and novel world with its glorious range of color is immediately visible in the paintings he produced shortly after his arrival, such as *Fatata te Miti* (By the Sea).

Like many other avant-garde artists, Gauguin had an aversion to the idea that painting should describe or imitate. He abhorred literary naturalism in any form and rather sought analogies between art and music. He wished his paintings to evoke sensations in the same way that combinations of notes—harmonies in music—evoked them. He wrote, "By the combination of lines and colors, under the pretext of some motif taken from nature, I create symphonies and harmonies which represent nothing absolutely real in the ordinary sense of the word but are intended to give rise to thoughts as music does."

These words seem to summarize this painting, with its bright and arbitrary colors, its absence of shadows or any other tonal modulations and its predilection for undulating arabesque shapes that so effectively convey the sense of the water's movement without resorting to literal description. In place of the evanescent color and quick brushwork associated with Impressionism, Gauguin offers lush reds and yellows and their complementary purples and greens applied so evenly that they resemble patches of cloth.

Chester Dale Collection

26¾ × 36 in (67.9 × 91.5 cm)

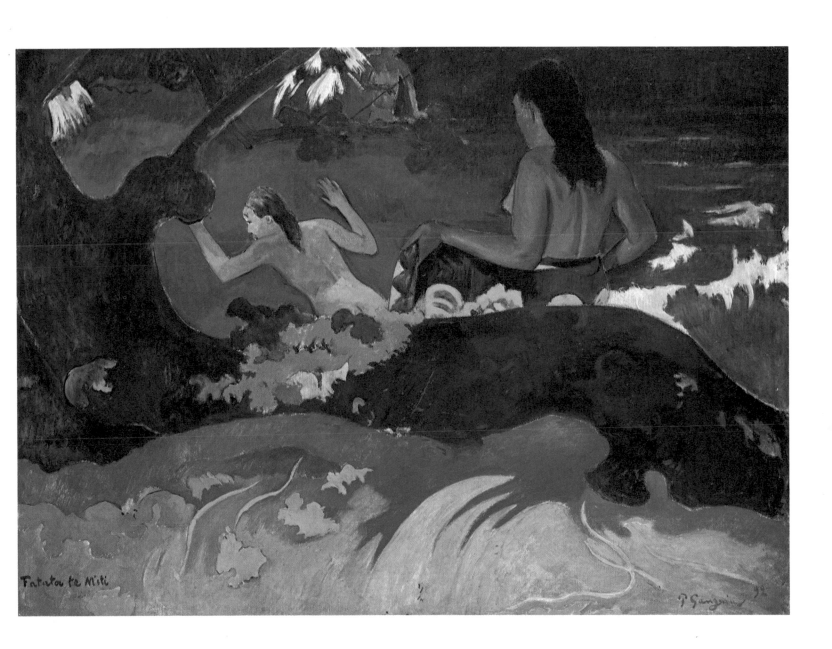

Paul Gauguin

PARAU NA TE VARUA INO (Words of the Devil)
(1892)

ON HIS ARRIVAL IN TAHITI, Gauguin installed himself in a simple wooden house in the middle of the country. There he lived quite happily among the natives, learning their customs and their religious beliefs. Although he had ceased to be a practicing Christian, Gauguin was impelled to seek for a deeper meaning in his life, and his sympathy for the natives of Polynesia can be likened to his deep respect for the simple piety of the peasants he had lived among in Brittany.

Many of the scenes he painted project an aura of mystery that sets them far apart from the matter-of-fact familiarity of most Impressionist themes. In *Words of the Devil* a dusky Eve-like young native girl seems perplexed by something as her gaze barely meets that of the viewer. Her pose recalls the modest demeanor of the goddess of love, Venus, who covers her breasts and genitalia. The relationship of the girl to the staring creature behind her is unexplained by anything in the painting. Both it and the girl seem to be aware of—indeed, transfixed by—an unseen presence. Perhaps both are under the spell of some whispering malevolent spirit.

In the South Pacific, Gauguin further cultivated the "primitivism" he had evolved in his earlier works. Abrupt changes of scale between figures, simplified modeling and the conscious manipulation of the decorative aspects of line and color make this one of his most haunting works.

Gift of the W. Averell Harriman Foundation in memory of Marie N. Harriman

36⅛ × 27 in (91.7 × 68.5 cm)

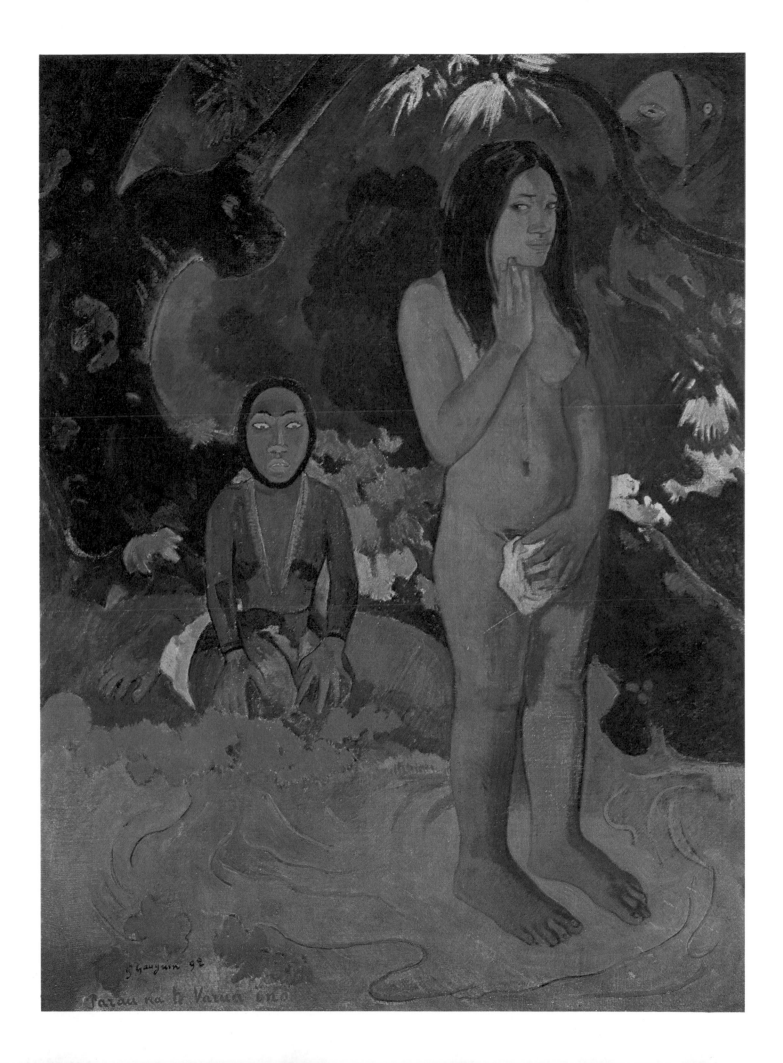

Henri de Toulouse-Lautrec (1864–1901)

QUADRILLE AT THE MOULIN ROUGE
(1892)

THE CHILDHOOD DISEASE THAT had deformed his legs and left him a dwarf cast a shadow over the life of this descendant of the counts of Toulouse. He preferred the noisy cafés and popular dance halls of Montmartre to the fashionable salons he might otherwise have frequented. Lautrec was perfectly at home in this center of bohemian life, and he delighted in recording all the denizens of the quarter who lived on the periphery of society.

Like Degas, whom he admired enormously, he was a magnificent draftsman, highly sensitive to the expressive and decorative power of line, and his powerful silhouettes and generally flat painting surface demonstrate that the Japanese prints that had such an impact on the Impressionists provided valuable models for Lautrec too.

Lautrec's themes are fairly limited. Except for an occasional portrait, he barely touched on other painting genres. Scenes such as the *Quadrille at the Moulin Rouge* reveal that the earlier Impressionists' dedication to modern life in its splendor or squalor was passed on to younger artists. Although he generally preserves the detachment of a Degas, there can be a bite to Lautrec's line, a harshness of color that underlines the particularly seedy or even decadent flavor of a place. His brush adroitly suggests the toughness of the blond-haired dancer, sparing nothing in its suggestion of her "charm" and "grace," yet clearly enjoying her spirit.

The chalky, dullish tones of the work are also reminiscent of Degas. They are the result of Lautrec's having used *gouache*, which is opaque rather than transparent watercolor and which gives much the same effect as pastels.

Chester Dale Collection

31½ × 23¾ in (80.1 × 60.5 cm)

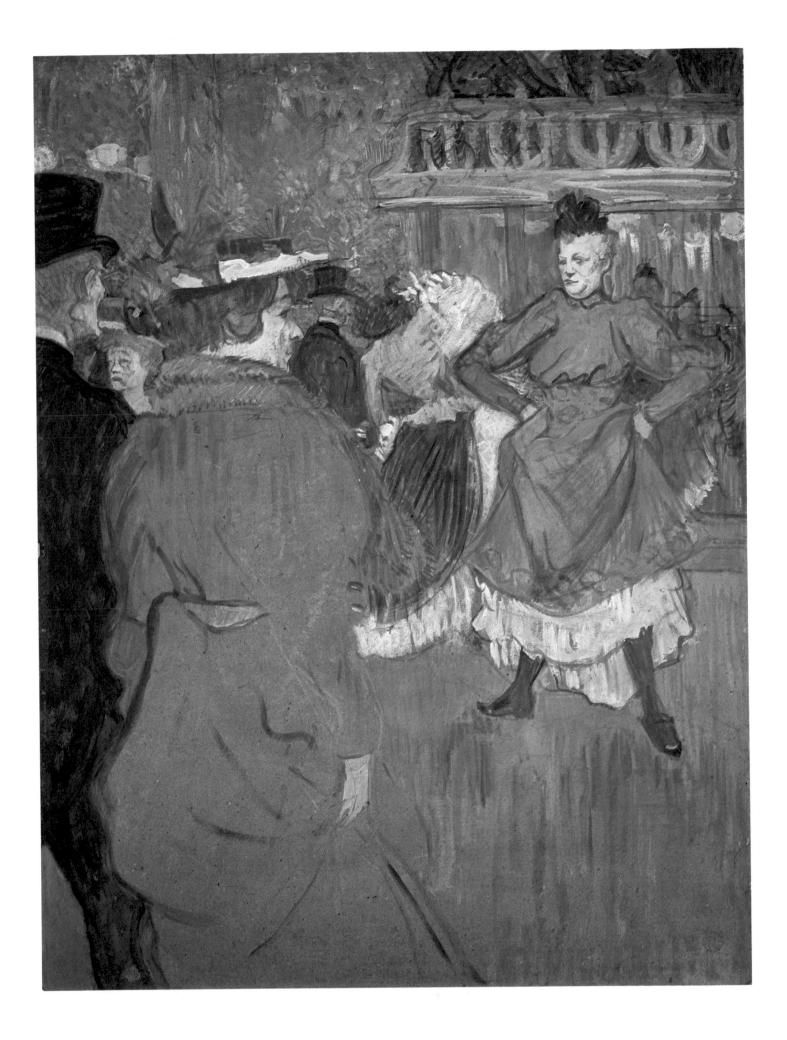

Henri de Toulouse-Lautrec

A CORNER OF THE MOULIN DE LA GALETTE
(1892)

THE *Moulin de la Galette* IS ANOTHER PAINTING that invites comparison with Degas and Manet in its masterful projection of a mood of isolation and loneliness.

The Moulin de la Galette was primarily the haunt of petty thieves, prostitutes and a shabby clientele who would be joined occasionally by members of the working class. It was one of Lautrec's favorite spots and provided him with the inspiration for many of his finest paintings.

This work, with its brilliant juxtaposition of figures, is one of the artist's most closely knit designs. Overlapping full or partial human forms, and alternating these with the fragments of flat tabletops, he creates a wonderfully active two-dimensional surface over which the eye restlessly wanders. The faces of the three main characters and, to a slightly lesser degree, the profile of a small blond-haired woman establish a shared destiny of boredom and emptiness despite the fact that no single figure engages another nor even seems to be aware of the other's presence. With his telling line, Lautrec could convey the crisp outline of a sleeve, the knowing "come-on" of a prostitute's gaze or the formal identity of an object like the small bowler worn by the slouching man. The role of color with the predominant accents of black, gray and a slightly bilious green is important, as it reinforces the drabness of their situation.

Chester Dale Collection

39½ × 35⅛ in (100.3 × 89.1 cm)

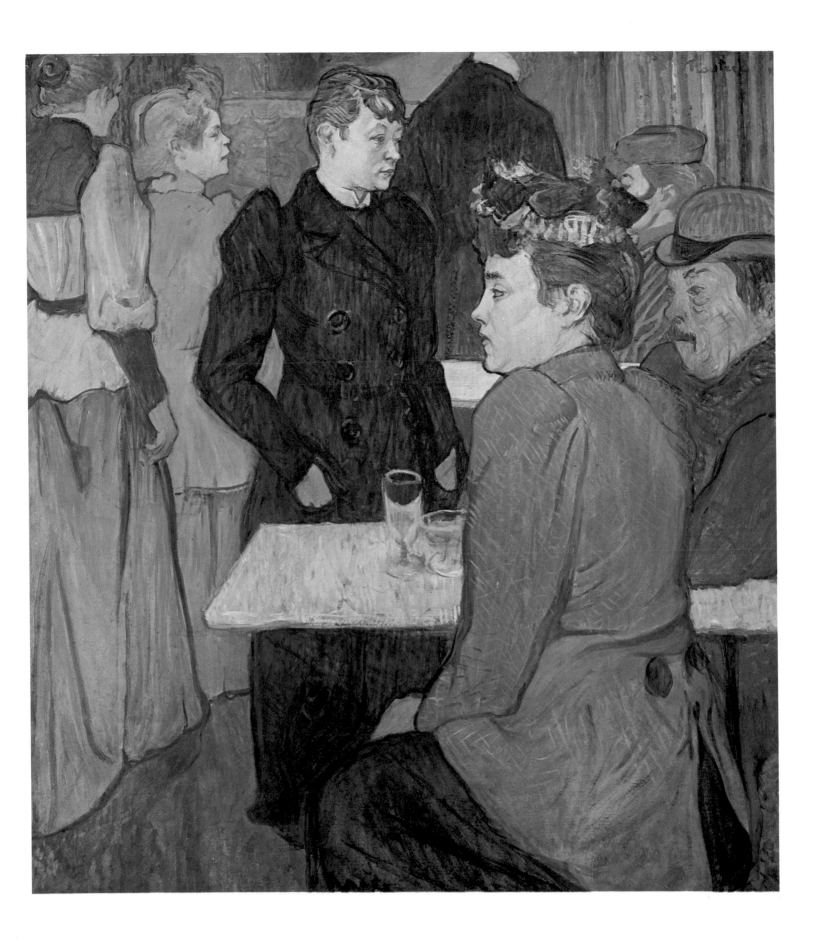

Henri de Toulouse-Lautrec

ALFRED LA GUIGNE
(1894)

THE CAFÉS, DANCE HALLS and brothels of Montmartre offered a fascinating if sometimes squalid visual panorama for Toulouse-Lautrec. The artist's keenly journalistic eye moved restlessly over singers and their aristocratic admirers, prostitutes and poets, sportsmen and small-time gangsters, recording their casual encounters and translating them into decorative syntheses that seem as vivid today as they were then.

The Alfred La Guigne who inspired this painting was an underworld character in a novel by Oscar Méténier, a writer who shared Lautrec's fascination with the low-life of Montmartre, and the painter has placed the gangster in a setting that recalls the Moulin de la Galette (plate 137). Probably both painter and writer were inspired by one of the colorful habitués of its bar. As the novelist used words to describe the physical and personal traits of his character, Lautrec projected these through the gestures of his line and through sensitive use of color. He exploited the natural color as well as the texture of the cardboard he painted on to create an overall warm tonality against which limited areas of bright paint could be played effectively.

From about 1894 on, Lautrec worked extensively on paper executing numerous color lithographs and posters. The experience not only made him more sensitive to the formal and decorative potentialities of the two-dimensional surface but enhanced his ability to create concise visual statements.

Chester Dale Collection
25¾ × 20¾ in (65.6 × 52.7 cm)

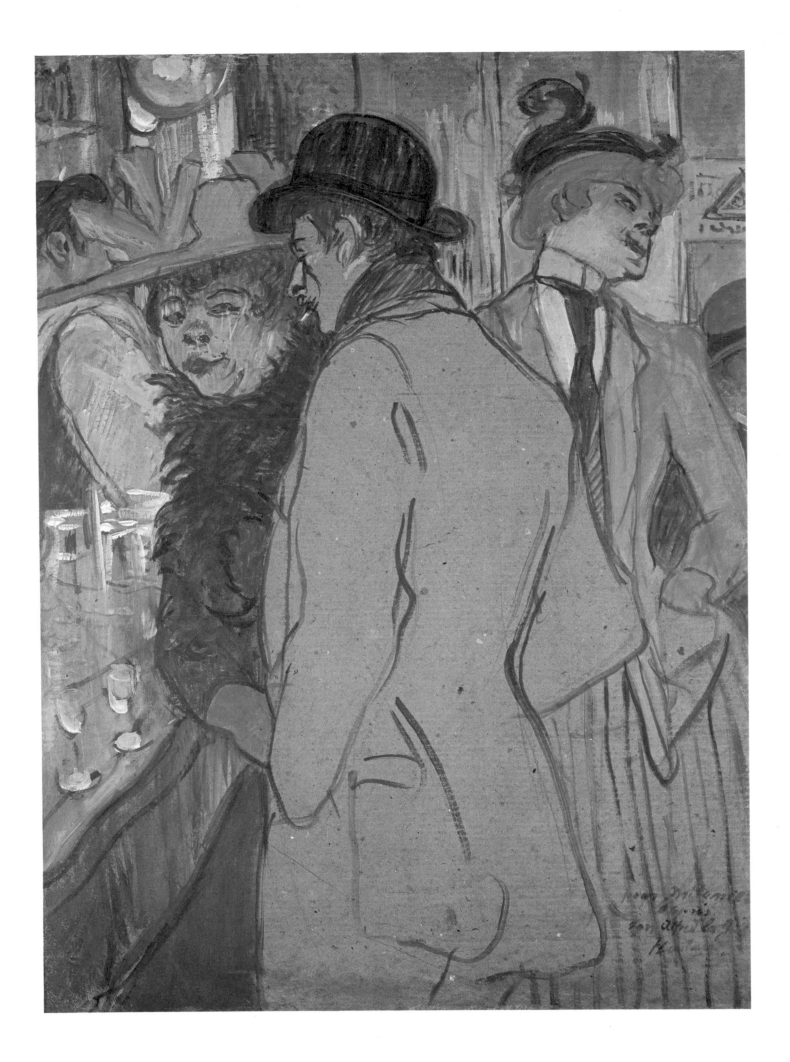

Paul Cézanne (1839–1906)

THE ARTIST'S FATHER
(1866)

LOUIS-AUGUSTE CÉZANNE WAS A successful hat manufacturer who had become a banker and who expected his only son to do likewise. After studying law briefly Cézanne persuaded his reluctant father to let him join a school friend, Émile Zola, who had journeyed from Aix-en-Provence to Paris to make a name as a writer. There he frequented the Académie Suisse, a popular studio where artists could work freely from a live model but where no formal instruction was given. When the young man subsequently announced his intention of becoming an artist, his father at first resisted but ultimately gave in and even provided a modest allowance until his death, when he left the fifty-seven-year-old painter a sizable fortune.

During his first years in Paris Cézanne failed the examination for entrance to the École des Beaux-Arts. As a consequence he relied on his own eye for training and on the advice of artists like Manet and Pissarro, whom he met through bzola, who was then writing art criticism. He revered Delacroix for his wonderful movement and strong color, but he was also drawn to the solid "concrete" forms and dull colors of Courbet. His initial paintings, like this portrait, reflect an awkward attempt to synthesize the romantic and realist elements represented by the older masters.

Despite his antipathy for his son's chosen profession, Louis-Auguste posed for his son a number of times. Some of the studies show the elder Cézanne similarly occupied in the reading of a newspaper. Most depict him as oblivious to or unacknowledging of an outside presence. The forms are vigorously if somewhat crudely defined, and a sense of durable solidity that results from the liberal use of the palette knife imparts a sense of personal character. Moreover, the darkish colors—black, gray, brown, cream—create a somber counterpart to the harsh dark outlines of the objects.

We know that Cézanne's relations with his father were frequently strained, probably because of a similar toughness of character. Zola described the older man as ". . . republican, bourgeois, cold, meticulous . . . " and these traits of character are certainly suggested by the portrait but not without a touch of sympathy.

While the stylistic vocabulary of this portrait is reminiscent of the realism of Courbet or even Daumier, the concern with structure that so clearly emerges looks ahead to the Eighties, when Cézanne would forge an independent, revolutionary visual language.

Collection of Mr. and Mrs. Paul Mellon
78¼ × 47 in (198.5 × 119.3 cm)

Paul Cézanne

HOUSE OF PÉRE LACROIX
(1873)

W HILE CÉZANNE EXHIBITED WITH the Impressionists in 1874 and gar-
nered the lion's share of negative criticism, this painting is one of the
few that was deemed acceptable by the Salon jury. A year before it was
shown Cézanne had begun to work out of doors in the village of
Auvers. With the help of Pissarro he gradually abandoned his unsuc-
cessful history and literary subjects and developed a lighter palette as
well. Like the Impressionists, he utilized ordinary subjects and sought
to capture the effects of light on surface as pure color by relinquishing
even finish in favor of a broken and at times scumbled surface often
created with a palette knife rather than a brush. Yet Cézanne did not
share the Impressionists' passion for spontaneity. This canvas has a
careful, organized look and a sense of physical and psychological
weight that are inconsistent with the look of Impressionist paintings.
The landscape fragment projects a compacted space that is the result of
the interacting color planes and of the careful alignment of verticals
and horizontals.

The poet and painter Émile Bernard, whose correspondence with
Cézanne provides great insight into his art, spoke of the artist's experi-
ence with Impressionism: "He had met Monet who dreamed of noth-
ing but sun and light and he succumbed in turn to the charms of the
great brightness; but he recovered little by little his calm and pondera-
tion. . . . " These qualities—calm and ponderation—imparted a sense
of monumentality to even the humblest of Cézanne's objects.

Chester Dale Collection
24⅛ × 20 in (61.3 × 50.6 cm)

142

Paul Cézanne

FLOWERS IN A ROCOCO VASE
(c. 1876)

THERE IS AN ENORMOUS DIFFERENCE between this vase of flowers done while Cézanne was still exhibiting with the Impressionists and the slightly later *Vase of Chrysanthemums* painted by Monet. In Monet's painting there is a vibrancy of color and surface that virtually imparts the same sensation as a living garden. Cézanne seems to have been bent on underlining the essentially artificial and decorative aspects of flower painting.

Copying the basic motif from a popular illustration, he emphasized the undulating arabesque of the rococo vase, and, in contrast to the vast majority of his paintings, one feels that this emphasis on the decorative is unusual for Cézanne. The blue flourishes of the vases serve as a color key not only for the flowers but as a way of harmonizing the still life with its dusty background.

Apart from the slightly frivolous quality of this work, the vigorous lines and substantial if somewhat pale colors provide clear testimony that its author was interested above all in forms.

Chester Dale Collection

28¾ × 23½ in (73 × 59.8 cm)

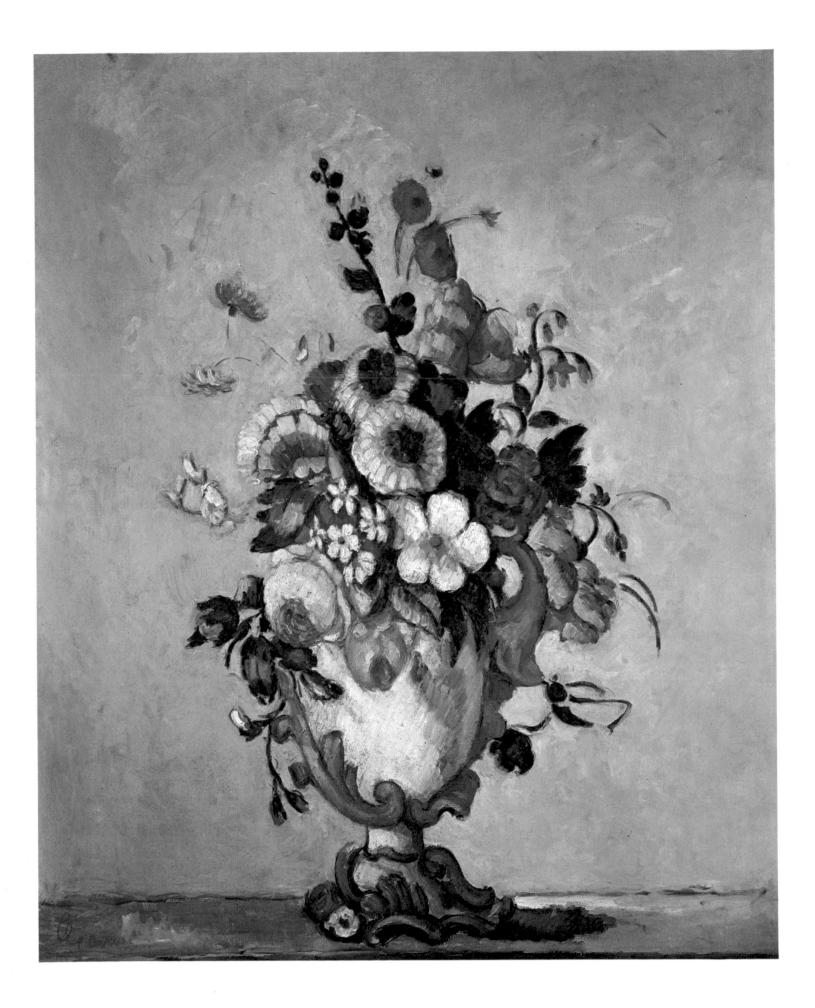

Paul Cézanne

HOUSES IN PROVENCE
(1880)

PAUL CÉZANNE, WHO PARTICIPATED in the first and third Impressionist exhibitions, had cultivated his taste for landscape painting with the encouragement of Camille Pissarro. For two years (1872–74) the painters worked closely together near Paris, as Cézanne slowly developed a type of painting that was to depart radically from Impressionism. In contrast, Cézanne stressed an important reflective stage between the receipt of the original visual experience and its pictorial representation. He carefully studied light and color and above all tonal values. His aim was to express the whole physical and spatial experience of a group of objects by means of color rhythms. Later in his life the artist would describe his works as "theory developed in contact with nature."

From the 1880s on, Cézanne worked in and around his native city of Aix-en-Provence. Because of the relative consistency of climate and light it was possible for him to return to a location, day after day, until he had achieved his pictorial goal. He wrote his friend Pissarro of his methods: "The sun is so terrific here that it seems to me as if the objects were silhouetted not only in black and white, but in blue, red, brown and violet. I may be mistaken but this seems the opposite of modeling."

Both Cézanne's desire to replace "traditional modeling and perspective by the study of color tones" and fundamental concern with clarity and underlying structural form can be seen in *Houses in Provence*. A strong sense of geometry is evident not only in the man-made elements but in nature itself. Moreover, despite the clarity of his tone—influenced to some degree by the practices of Impressionism—the painting exudes a sense of timelessness and calm that are diametrically opposed to the very tenets of Impressionism.

Collection of Mr. and Mrs. Paul Mellon

25⅝ × 32 in (65 × 81.3 cm)

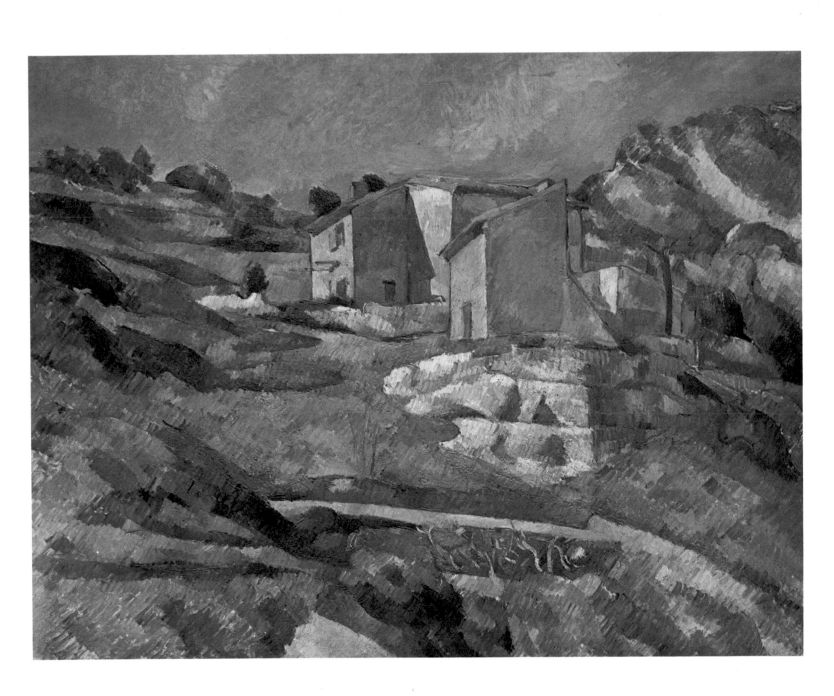

Paul Cézanne

THE BATTLE OF LOVE
(c. 1880)

THIS SMALL CANVAS HAS presented some stylistic and iconographic problems for students of Cézanne. One of the relatively few erotic themes he painted, it has been dated as early as 1875 and as late as 1886. The romantic subject matter and turbulent, swirling forms relate it for some to the artist's early enthusiasm for Baroque art and for the brushwork of Delacroix. Cézanne had enormous respect for the tradition of history or mythological painting which frequently included figures within a landscape setting, and during the Seventies he began to paint the studies of nude bathers that would culminate in his most monumental works.

It is possible that this painting of four couples in various stages of amorous combat is an adaptation of an earlier picture that Cézanne had seen in the Louvre, where young artists copied the old masters. On the other hand, its enigmatic but highly emotional content may be allegorical, referring to a personal frustration or obsession. The inclusion of an attacking dog in the lower right-hand corner of the work has been interpreted as a negative "comment" on the activity since it is known that Cézanne disliked dogs. It is also possible that all the subject matter is merely a device that permits the painter to explore color and line in terms of a more dynamic design than was feasible in his pure landscape or still-life paintings.

Whatever Cézanne's motivations, the impact of the painting is hardly erotic; the lines are too insistent and the colors too harsh for the viewer to experience the sensuality inherent in the theme. Indeed, the painting strikes the viewer as almost a caricature.

Gift of the W. Averell Harriman Foundation in memory of Marie N. Harriman

14⅞ × 18¼ in (37.8 × 46.2 cm)

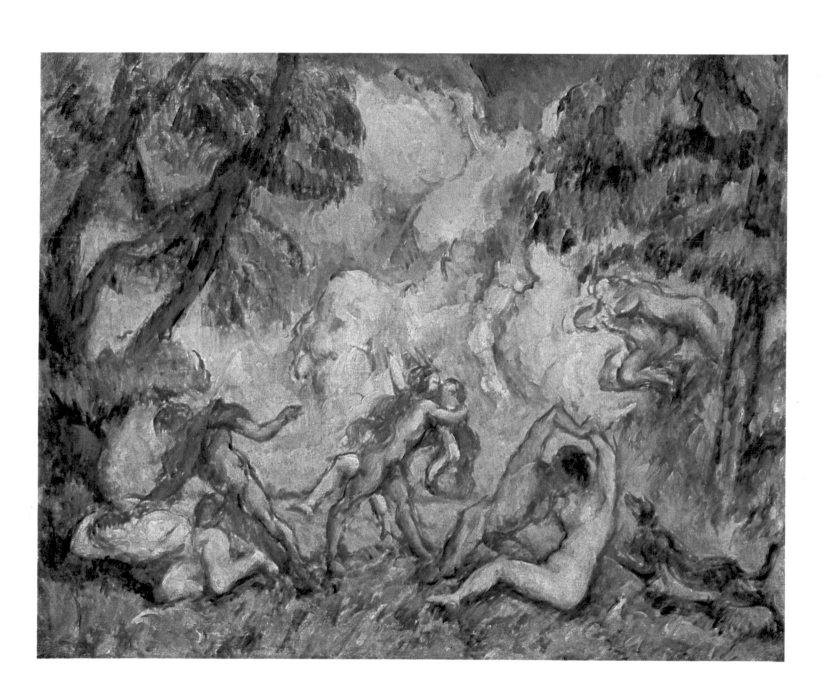

Paul Cézanne

AT THE WATER'S EDGE
(c. 1890)

At the Water's Edge IS A LANDSCAPE THAT derives from the artist's most active period (1883–95). Throughout those years, Cézanne was striving to find a balance between an intellectual concept and a direct perception of forms. He had long admired the seventeenth-century French classicist Nicolas Poussin, a painter esteemed for his carefully constructed, idealized and usually didactic landscapes. Poussin's incisive lines and subordinate colors, like his own, seem more directed to the intellect than to the senses. While Cézanne responded to Poussin's systematic approach, he was adamant about working directly from nature: ". . . good studies made after nature, that is the best thing."

This painting reflects some of the struggle that went into Cézanne's art. In it he sought to express energy and repose, mutation and permanence. For him, colors and lines created weight and substance; they were the building blocks that in separating, overlapping, receding or advancing created a highly active surface pattern. If one were to focus on a given section of this painting, the impression might be confusing, but in context each "unit" of color contributes to a totality of form that is a synthesis of perceived and known characteristics.

Gift of the W. Averell Harriman Foundation in memory of Marie N. Harriman

28⅞ × 36½ in (73.3 × 92.8 cm)

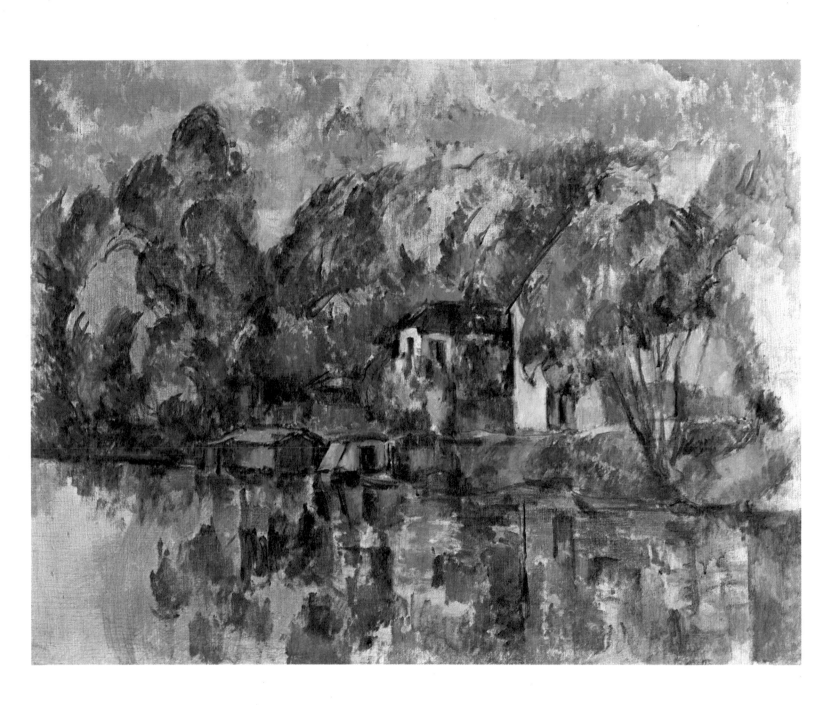

Paul Cézanne

THE ARTIST'S SON, PAUL
(1885–90)

As a portrait painter, Cézanne worked rather slowly. It was rumored that the portrait of his friend and dealer Ambroise Vollard required more than one hundred sittings. There is no question that many of his portraits project a rather stiff or static quality that is, in fact, little different in feeling from one of the artist's still-life paintings. The traditional problems of portraiture, more specifically, the possibility of suggesting nuances of character or of mood, never really seem to have engaged him. What he was after, what he pursued relentlessly from his early heavily impastoed studies of his Uncle Dominique to this more thinly painted but rather dour portrait of his teenage son, Paul, was the elimination of every trace of anecdote or unessential detail in an effort to condense and clarify the material and objective reality of the sitter. This is not to say that Cézanne neglected physiognomical or anatomical characteristics altogether. However, there is no question that he chose to relinquish that sense of a given moment or mood that so characteristically identifies the Impressionist portraits of Degas or Renoir.

Chester Dale Collection

25¾ × 21¼ in (65.3 × 54 cm)

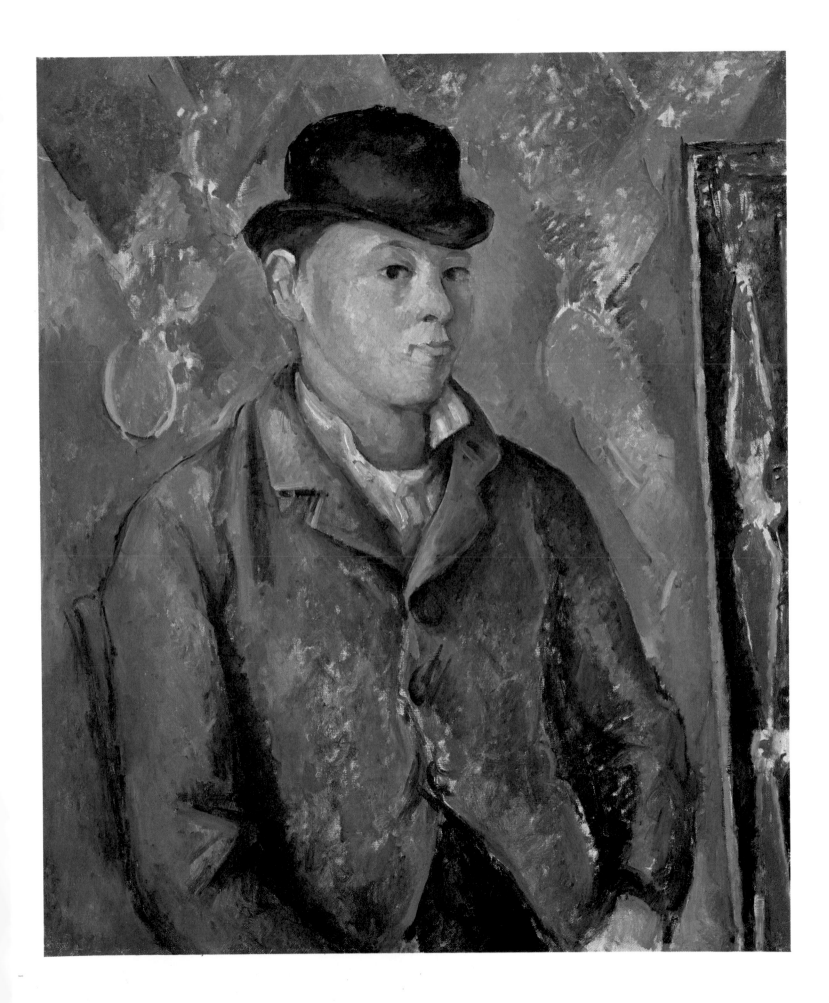

Paul Cézanne

STILL LIFE WITH PEPPERMINT BOTTLE
(c. 1894)

By the middle of the 1880s Cézanne had deserted Impressionism to concentrate on the development of a new pictorial order. Cézanne could not depict objects without examining and reconstructing them within the borders of his canvas.

Still-life painting was not very popular with the Impressionists, but it holds an important place in Cézanne's *oeuvre*. Unlike the seventeenth-century Dutch artist who sought to gratify the public's sensuous response to objects, Cézanne was motivated by a desire to transcend the object's appearance and capture its formal essence.

Cézanne's *Still Life with Peppermint Bottle* recalls the highly organized structural studies of the eighteenth-century painter Chardin. Looking at the forms, one is immediately aware that the artist has taken liberty with certain shapes—that in the carafe there is a purposeful distortion of the round bowl and that the relation of apple to apple, glass to carafe and napkin to cloth is also carefully manipulated. The gravity and scale of the work, not to mention the sobriety of the colors, seem more appropriate to a landscape painting and remind us that whether he was dealing with mountains or the folds of a tablecloth, human beings or a wineglass, Cézanne imbued his forms with a monumentality that transcends their nominal identity. In so doing he provided the example for subsequent painters who would forge his modernist vision of painting into a truly abstract art.

Chester Dale Collection

26 × 32⅜ in (65.9 × 82.1 cm)

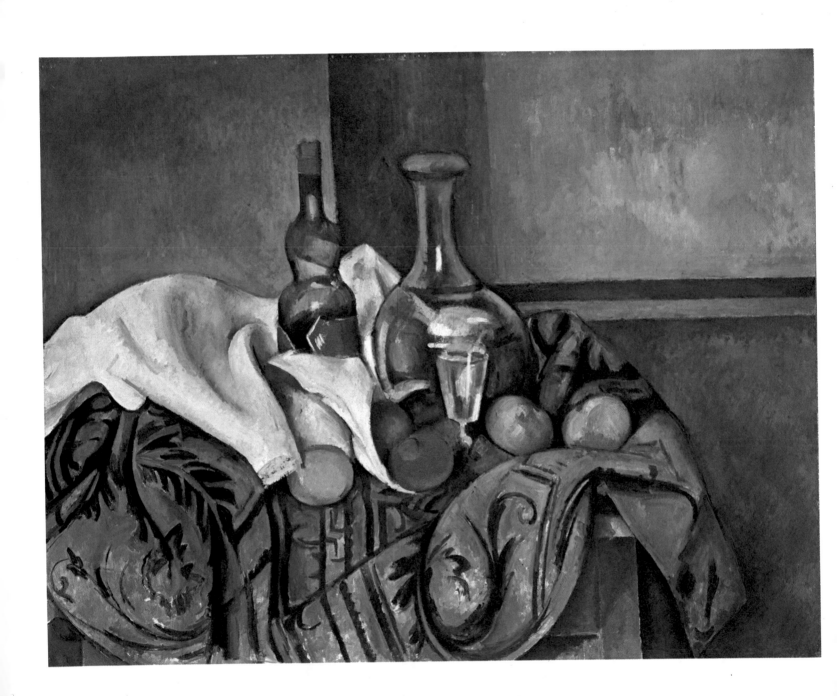

Paul Cézanne

LE CHÂTEAU NOIR
(1900/04)

IN THE LAST YEARS OF HIS life, Paul Cézanne's painting pushed well beyond the known limits of representation toward a more profound consideration of the inner structure of nature that would lead increasingly to abstraction. He began working in the rugged area east of Aix and was particularly drawn to a large, deserted estate, its overgrown park dominated by a forbidding, fortresslike structure that was called Le Château Noir (Black Country House) by locals despite the fact that the color of its walls was the intense yellow-ocher of stone from a nearby quarry.

Placing himself at some distance from the building, Cézanne recreates the visual dialogue between inherently geometric or organic forms in nature, forcing us to perceive them as subtly overlapping or interlocking planes of blue, green and ocher. The patches of color are less broadly rendered than in Cézanne's earlier work, and there is a greater emphasis on color as receding or advancing surface.

Cézanne's insistence on distinguishing between the representation of objects and what might be termed the essence of them underscores a cognitive process in which both painter and viewer are implicitly involved and signals the arrival of Modernism. The single-mindedness that prompted Cézanne to return again and again to certain themes as he sought for essential truths prefigures the attitudes of the great modern masters, Picasso and Matisse. In these lonely struggles with the landscape of his native Aix, Cézanne virtually reinvented painting. To quote the critic Geffroy: "He loved this and he loved nothing but this, to the point of forgetting everything that was not this, of remaining for hours . . . and days, before the same spectacle determined to penetrate within it, to understand it, to express it—an obstinate creature, a seeker, diligent in the manner of the shepherds who discovered in the solitude of the fields, the beginning of art, of astronomy, of poetry."

Gift of Eugene and Agnes Meyer

29 × 38 in (73.7 × 96.6 cm)

Paul Cézanne

STILL LIFE WITH APPLES AND PEACHES
(c. 1905)

IN THE LAST DECADE of his life, Paul Cézanne produced a number of still lifes. While the scale of these works ranges from roughly two feet in height to about three feet in width, their overall impact is one of transcendant monumentality. Painted in the studio where the artist could contemplate their components over long periods of time, the "great still lifes" constitute heroic variations on a theme: the few familiar objects that populate the compositions—pitchers, plates, drapery, fruit—belong to the repertoire of traditional still life, yet their identity and function have been radically altered in the course of Cézanne's labors.

The *Still Life with Apples and Peaches,* painted about a year before the master's death, is characterized by deliberate almost elemental forms and relatively somber color. In painting this work, Cézanne eschewed literal likenesses as he sought after more enduring and therefore more "real" forms. He also abandoned the rational, balanced space that was the heritage of Renaissance painting in his effort to reconstruct what the eye actually sees. As he creates new formal relationships, the painter forces the viewer's eye from shape to shape and color to color making him aware of the weightiness or lightness of the pictorial elements in the process. Color plays a crucial role. At times, the warm reds and yellows of the fruit are played against the darker, almost melancholy browns and blues of the drapery, wall and table, with the result that the composition seems split diagonally in two parts: the left side appears to recede, while the right advances. Yet color also serves as a unifying element: the browns, blues and mauves invade the whites of the pitcher, flower-holder and napkin, providing a new basis for relating the various objects. Finally, the relatively homogeneous paint surface contributes to the new sense of pictorial order that emerges.

Like his last landscapes, Cézanne's "great still lifes" offered a sustained discourse on the nature of seeing. In the process of redefining the conventional character of the genre and of our response to it, they provided a new vision of what painting might be.

Gift of Eugene and Agnes Meyer

32 × 39⅝ in (81.2 × 100.6 cm)